Singular Forms (Sometimes Repeated):
Art from 1951 to the Present

Singular Forms (Sometimes Repeated):
Art from 1951 to the Present

[Solomon R. Guggenheim Museum]

GuggenheimMUSEUM

Published on the occasion of the exhibition
Singular Forms (Sometimes Repeated):
Art from 1951 to the Present

Organized by Lisa Dennison and
Nancy Spector

Solomon R. Guggenheim Museum,
New York, March 5–May 19, 2004

Guggenheim Museum Publications: 1071
Fifth Avenue, New York, New York 10128

Available through D.A.P./Distributed Art
Publishers: 155 Sixth Avenue, 2nd floor
New York, New York 10013
Tel.: (212) 627-1999 Fax: (212) 627-9484

Distributed outside the United States and
Canada by Thames & Hudson, Ltd., London

Design: 2x4: Alex Lin, Susan Sellers

Production: Lara Fieldbinder, Tracy L.
Hennige

Editorial: Elizabeth Franzen

Printed in Germany by Cantz

Inside front cover: James Turrell, *Afrum I*,
1967 (full caption, page 124)

Inside back cover: Rachel Whiteread,
Untitled (One Hundred Spaces), 1995
(full caption, page 161)

Contents

Lenders to the Exhibition

Paula Cooper Gallery, New York

D'Amelio Terras, New York

Anthony D'Offay Gallery, London

Mandy and Cliff Einstein

Electronic Arts Intermix, New York

Arne and Milly Glimcher

Robert Gober

Barbara Goldfarb, New York

The Estate of Felix Gonzalez-Torres

Collection Herbert, Ghent

Maireluise Hessel Collection on permanent
loan to the Center for Curatorial Studies,
Bard College, Annandale-on-Hudson, New York

Roni Horn

Casey Kaplan, New York

Wolfgang Laib

Glenn Ligon

Matthew Marks Gallery, New York

Allan McCollum

The Museum of Modern Art, New York

Andrew Ong

The Panza Collection

Private Collection

Private Collection, courtesy of Edward Boyer
Associates

Private Collection, courtesy of PaceWildenstein

Private Collection, New York

Robert Rauschenberg

Kathy and Keith Sachs, courtesy Matthew Marks
Gallery, New York

Frank Stella

Rudolf Stingel

Michael Werner Gallery, New York and Cologne

Thea Westreich and Ethan Wagner, New York

Preface

Singular Forms (Sometimes Repeated): Art from 1951 to the Present is the third in a series of exhibitions highlighting the greatest areas of strength in the Guggenheim Museum's world-renowned permanent collection. In summer 2003, the Guggenheim presented *From Picasso to Pollock: Classics of Modern Art*, an exhibition featuring classic masterpieces of painting and sculpture from the first half of the twentieth century; with *Moving Pictures* in 2002, the museum showcased its important and highly innovative concentration of contemporary photography and video. Drawing on the Guggenheim's exceptional holdings of Minimalist and Post-Minimalist painting and sculpture, *Singular Forms* examines the impulse toward the elemental in postwar art. The fact that all three of these exhibitions have filled the museum's Frank Lloyd Wright–designed rotunda and adjacent tower galleries without overlapping in content is a testament to the richness and depth of the Guggenheim's impressive, ever-growing collection. I would like to acknowledge Lisa Dennison, Deputy Director and Chief Curator, and Nancy Spector, Curator of Contemporary Art, who deftly organized *Singular Forms*, and who also oversee the museum's collection-building initiatives with great care and dedication to the institution's unique history.

The exhibition also includes some key loans from private collections and individual artists, which augment the historical and contemporary sections of the presentation and further articulate its core theme of aesthetic reduction and formal clarity. I am immensely grateful to the collectors and artists, listed elsewhere in this publication, who have so generously allowed us to share their precious works for the duration of this presentation. As the Guggenheim has so successfully done in the past, we have identified a select number of these important loans as acquisition priorities for the institution while we continually strive to build a collection that reflects the most significant cultural productions of our time.

Thomas Krens, Director
The Solomon R. Guggenheim Foundation

Acknowledgments

It has been forty years since the first examples of the radically reduced art form that came to be known as Minimalism were exhibited. During the ensuing decades Minimalism, which was quickly codified as an art movement by an informed and sympathetic critical press, was alternately emulated, extrapolated from, rejected, appropriated, and manipulated by successive generations of artists grappling with the efficacy of pure abstraction. In recent years Minimalism has become the object of intense scholarly scrutiny as doctoral dissertations, lengthy academic tomes, and museum exhibitions on the subject have been produced and widely distributed. Our approach to the subject, filtered as it is through the Guggenheim Museum's own substantial holdings of Minimalist and Post-Minimalist art, is rather unorthodox. Rather than investigating the movement as a discrete chronological entity with a set group of practitioners (a contested assumption as it is), in this exhibition, *Singular Forms (Sometimes Repeated): Art from 1951 to the Present*, we are examining the prevalence of a reductive sensibility, which both pre- and post-dates the 1960s, when Minimalism emerged and reached its apex. The installation, therefore, spans from Robert Rauschenberg's iconoclastic *White Paintings* (1951) to Karin Sander's nearly invisible wall rubbings (2003); from Carl Andre's inert, wooden cubes (1960) to Liam Gillick's site-specific, powdered-black, open metal cube (2004).

This publication, designed to accompany and document the exhibition, includes reproductions of works by every artist included in the presentation. But its contents reach well beyond the visual arts, which is the sole subject of the show. Since reduction, restraint, and lucidity may be found in many other cultural disciplines, including architecture, design, music, dance, and film, we commissioned several texts to examine this shared phenomenon. To that end, we are not positing that Minimalism in the visual arts originated from the same sources as that of architecture or fashion, but, collectively, the essays do identify some significant, seminal figures and key cross-pollinating activities that influenced the evolution of an interdisciplinary reductivist impulse that informs contemporary cultural production.

As in any project at the Guggenheim, an exhibition of this scale could not have happened without the sustained support of Thomas Krens, Director of the Solomon R. Guggenheim Foundation, and numerous members of the Guggenheim staff. Similarly, we would like to recognize Anthony Calnek, Deputy Director of Publications and Communications, and Marc Steglitz, Deputy Director for Finance and Operations, for their keen oversight of exhibition programming at the museum. We are also grateful to Karen Meyerhoff, Managing Director for Collections, Exhibitions, and Design, for her attention and expertise. Marylouise Napier, Registrar, and Janet Hawkins, Project Registrar, skillfully coordinated the transportation of artworks in the exhibition. Elizabeth Levy, Director of Publications, and Elizabeth Franzen, Managing Editor, handled the myriad details of catalogue production with great care. We would also like to thank editors Jennifer Knox White and Edward Weisberger. Joan Young, Assistant Curator, and Ted Mann, Collections Curatorial Assistant, with the help of Susan Cross, Associate Curator, coordinated all aspects of this exhibition, including essential research on the collection, artist correspondence, and loan negotiations. We would also like to thank Susan Davidson, Curator, and Brooke Minto, Administrative Curatorial Assistant, for their essential assistance with loans.

We would also like to thank our colleagues at numerous organizations, galleries, and private collections for accommodating myriad research inquiries and requests: Douglas Chrismas, Ace Gallery; Robert Haller, Anthology Film Archives; Jennifer Belt, Art Resource; Christina Sterner, Baryshnikov Productions, Inc.; Stephanie Berger; Björk; John Bowsher; Laura Kuhn, The John Cage Trust; Emily Liebert, The Chinati Foundation; Steve Henry, Abigail Hoover, and Elissa Ruback, Paula Cooper Gallery; Chris D'Amelio and Brian Sholis, D'Amelio Terras; Aaron Rosenblum, Dance Theater Workshop; The Designers Republic; Anthony d'Offay, Marie Louise Laband, and Laura Ricketts, Anthony d'Offay Gallery; Electronic Arts Intermix, New York; Marion Faller; Millicent Wilner, Gagosian Gallery; Claudia Carson, Robert Gober Studio; Carol and Arthur Goldberg; Michelle Reyes, The Felix Gonzalez-Torres Foundation; Dr. Michaela Unterdörfer,

11

Hauser and Wirth Collection; Anton Herbert; Barbara Bryan, John Jasperse Company; Elein Fleiss and Madeleine Hoffmann, The Judd Foundation; Olivier Belot, Galerie Judin Belot; Chana Budgazad, Casey Kaplan; Let There Be Neon; Susanna Singer, Mitsuru Chiba, Sachiko Cho, Renee Ruth Ickes, Rob Nelson, and Anthony Sansotta, Sol LeWitt Studio; Jeffrey Peabody, Victoria Cuthbert, and Adrian Turner, Matthew Marks Gallery; Marian Zazeela, The MELA Foundation; Sarah Michelson; Jessica Brandrup, Modern Art Museum of Fort Worth; Ann Goldstein, Jang Park, and Paul Schimmel, The Museum of Contemporary Art, Los Angeles; John Elderfield, Cora Rosevear, and Mikki Carpenter, The Museum of Modern Art, New York; Elizabeth Armstrong and Tom Callas, Orange County Museum of Art; Carsten Nicolai; Trevor Jackson, Output Recordings; Arne Glimcher and Jeff Burch, PaceWildenstein; Nicholas Barba and Eriko Shimazaki, John Pawson; Chee Pearlman; Friedrich Petzel and Jessie Washburne-Harris, Friedrich Petzel Gallery; Photofest; Audrey Rasper and Olivier Zahm, *Purple* magazine; David White, Robert Rauschenberg Studio; Shaun Caley and Julie Chiofolo, Regen Projects; Mortimer D.A. and Jacqueline Sackler; Noèmie Lafrance, Sens Production; Sarah Auld, The Tony Smith Estate; David Leiber, Whitney Odell, and Katharine Smith, Sperone Westwater; Eveline Camathias, Therme Vals; Matthew Schreiber, James Turrell Studio; Jill Vetter, Walker Art Center; Bethany Izard, Lawrence Weiner Studio; Gordon VeneKlasen and Jason Duval, Michael Werner Gallery; Jay Jopling, White Cube; Anita Duquette, Whitney Museum of American Art; David Woo; David Zwirner and Eugenia Lai, David Zwirner Gallery.

We are also grateful for Casey Kaplan's generous support of the creation of a new work by Liam Gillick for this exhibition.

The authors of the essays included in this publication deserve special mention for producing provocative and informative texts under the pressure of a rather tight deadline. We truly appreciate the original contributions of Andrea Codrington, Drew Daniel, Bruce Jenkins, Gia Kourlas, Deyan Sudjic, and Mark C. Taylor, whose individual voices make this book an innovative meditation on minimalism in all its various manifestations. The elegance and economy of the design of this publication is a testament to the talents of Susan Sellers and Alex Lin of 2x4, whose keen understanding of the material made this a truly fruitful collaboration.

The inspired design of the exhibition was created by architect Michael Gabellini, whose subtle and sensitive interventions into the museum prove his intrinsic respect for the art and his own talent for shaping space with the elemental forms of light and volume.

And finally, we would like to thank a number of the artists included in the exhibition who collaborated closely with us to identify, install, and in some cases, fabricate their works: Liam Gillick, Robert Gober, Jene Highstein, Roni Horn, Robert Irwin, Koo Jeong-a, Wolfgang Laib, Sol LeWitt, Glenn Ligon, Allan McCollum, Robert Rauschenberg, Charles Ray, Gerhard Richter, Karin Sander, Frank Stella, Rudolf Stingel, James Turrell, Meg Webster, Doug Wheeler, and Lawrence Weiner.

Lisa Dennison
Deputy Director and Chief Curator

Nancy Spector
Curator of Contemporary Art

Project Team

Curatorial

Lisa Dennison, Deputy Director and Chief Curator

Nancy Spector, Curator of Contemporary Art

Susan Cross, Associate Curator

Ted Mann, Collections Curatorial Assistant

Joan Young, Assistant Curator

Lisa Panzera, Research Assistant

Melitta Firth and Emily Rogath, Interns

Art Services and Preparations

Scott Wixon, Manager of Art Services and Preparations

David Bufano, Chief Preparator

Jeffrey Clemens, Associate Preparator

Derek DeLuco, Technical Specialist

Mary Ann Hoag, Lighting Designer

Barry Hylton, Senior Exhibition Technician

Elisabeth Jaff, Associate Preparator for Paper

Paul Kuranko, Multimedia Support Specialist

Michael Sarff, Construction Manager

Hans Aurandt, Art Handler

Pat Holden, Art Handler

Liza Martin, Art Handler

Colin O'Neill, Art Handler

Chris Williams, Art Handler

Conservation

Julie Barten, Conservator, Exhibitions and Administration

Mara Guglielmi, Paper Conservator

Eleonora Nagy, Sculpture Conservator

Carol Stringari, Senior Conservator, Contemporary Art

Clemencia Vernaza, Getty Conservation Fellow

Education

Kim Kanatani, Gail Engelberg Director of Education

Pablo Helguera, Senior Education Program Manager, Public Programs

Sharon Vatsky, Senior Education Program Manager, School Programs

Exhibition and Collections Management and Design

Karen Meyerhoff, Managing Director for Collections, Exhibitions, and Design

Dan Zuzunaga, Exhibition Design Assistant

External Affairs

Helen Warwick, Director of Individual Giving and Membership

Kendall Hubert, Director of Corporate Development

Gina Rogak, Director of Special Events

Stephen Diefenderfer, Special Events Manager

Peggy Allen, Special Events Coordinator

Fabrications

Peter Read, Manager of Exhibition Fabrications and Design

Stephen Engelman, Technical Designer/Chief Fabricator

Global Programs, Budgeting and Planning

Christina Kallergis, Senior Financial Analyst

Graphic Design

Marcia Fardella, Chief Graphic Designer

M. Concetta Pereira, Production Coordinator

Christine Sullivan, Designer

Integrated Information and Management

Danielle Uchitelle, Information Technology

Legal

Brendan Connell, Assistant General Counsel

Maria Pallante-Hyun, Intellectual Property Counsel and Licensing Representative

Marketing

Laura Miller, Director of Marketing

Ashley Prymas, Manager of Marketing

Photography

David M. Heald, Director of Photographic Services and Chief Photographer

Kimberly Bush, Manager of Photography and Permissions

Public Affairs

Betsy Ennis, Director of Public Affairs

Jennifer Russo, Public Affairs Coordinator

Publications

Elizabeth Levy, Director of Publications

Elizabeth Franzen, Managing Editor

Meghan Dailey, Associate Editor

Lara Fieldbinder, Production Assistant

Tracy Hennige, Production Assistant

Stephen Hoban, Assistant Editor

Jennifer Knox White, Editor

Melissa Secondino, Production Manager

Edward Weisberger, Editor

Registrar

Meryl Cohen, Director of Registration and Art Services

Janet Hawkins, Project Registrar

Marylouise Napier, Registrar

Visitor Services

Stephanie King, Director of Visitor Services

Yseult Tyler, Manager of Visitor Services

Catalogue Design

2x4

Alex Lin

Susan Sellers

Exhibition Design

Gabellini Associates
Michael Gabellini, Design Partner

Daniel Garbowit, Managing Partner

Kimberly Sheppard, Design Partner

Kevin Davis, Project Associate

Mark Kolodziejczak, Project Architect

Matteo Minchilli, Architect

Neil Epstein, Graphic Designer

13

Introduction
Nancy Spector

In 1991 and 1992 when the Guggenheim Museum acquired over three hundred works of Minimalist, Post-Minimalist, and Conceptual art from the renowned Panza di Biumo Collection, the institution made a profound commitment to the kind of radical experimentation that has come to define these interrelated chapters in the history of contemporary art.[1] During the 1960s and 1970s, in the spirit of broader countercultural movements, artists shunned the traditional categories of painting and sculpture, as well as the expressive content of much aesthetic representation, to explore new modes of artmaking. This resulted in a plethora of unprecedented aesthetic and critical practices, ranging from industrially produced geometric abstractions that negated the hand of the artist to text-based investigations into the meaning of art itself. Though disparate in intent and formal resolution, the works that fall under the art-historical rubrics of Minimalism, Post-Minimalism, and Conceptual art share an abiding impulse to pare a work of art down to its elemental core—be it a perfect cube, a basic, repetitive gesture, or a simple, declarative phrase. In many cases, the object of art disappeared altogether, leaving in its wake nothing more than the textual articulation of an idea or an ephemeral, performative action.

Such a generalization about a common reductivist drive behind various avant-garde activities in the late 1960s may seem irresponsibly dismissive of the fundamental, theoretical distinctions between such canonical works as Donald Judd's pristine cubic forms, Bruce Nauman's videotaped studio exercises, Joseph Kosuth's dictionary definitions, and James Turrell's transcendental light installations. But such are the dangers and pleasures of formal analysis. Connections and comparisons may on occasion be based on morphological likeness alone, which can, in the best of cases, lead to new insights into how an artwork functions in the world. *Singular Forms (Sometimes Repeated): Art from 1951 to the Present* begins with this premise. Drawn primarily from the Guggenheim Museum's permanent collection—with particular emphasis on its in-depth Panza holdings—this exhibition focuses on how a "minimalist" sensibility suffused many of the most significant artistic practices of the 1960s and

early 1970s. To this end, the crux of the show comprises key selections from the museum's classic Minimalist collection—including sculptures by Carl Andre, Dan Flavin, Judd, and Robert Morris, and paintings by Robert Mangold, Brice Marden, and Robert Ryman. But this constitutes only the nucleus of a more extensive investigation that analyzes Minimalism as part of a historical continuum. The exhibition posits Minimal art—with its adherence to an utmost precision of form—as an aesthetic phenomenon that radiates both backward and forward in time, informing, retrospectively, the work of "precursors" who explored the potential of radical reduction and, later, the work of "successors" who appropriated the vocabulary for different theoretical and critical ends.

Speaking in the broadest art-historical terms, a reductive sensibility pervades much of the avant-garde art of the twentieth century. Spanning from its earliest decades to the new millennium, a progressive aesthetics of formal clarity developed during the century in tandem with the evolution of abstraction. During the 1920s, Piet Mondrian's omission of all extraneous details from his geometric paintings was prompted by a utopian impulse that equated purity of form with spiritual transcendence. In Russia, at roughly the same time, the Constructivists' eschewal of any decorative flourish associated with bourgeois taste represented a revolutionary disavowal of class-based connoisseurship and the romantic notion of artistic subjectivity. At the heart of these movements toward an increasingly nonreferential, elemental form was the desire to create a new, universal aesthetic language.

This reductivist impulse found renewed vigor during the 1950s in reaction to Abstract Expressionism with its painterly excesses and invocations of individual unconscious states. Tony Smith's unadulterated, geometric forms, Ellsworth Kelly's investigations of pure color and line, and Ad Reinhardt's meditations in black served as critical counterpoints to the rhetorical gesture found in much Abstract Expressionist art. Robert Rauschenberg's multipaneled, all-white paintings from 1951 similarly rejected the heroics of Abstract Expressionism, their blank surfaces designed to register the shadows of their viewers and the temporality of the viewing experience. So

1 With the acquisition of the Panza Collection, the Guggenheim has devoted great institutional resources to the study, preservation, publication, and exhibition of works from this seminal period in postwar art. The museum's Conservation Department received grants from the Institute of Museum and Library Services and the Getty Grant program for the research and treatment of works by Donald Judd, Robert Mangold, Brice Marden, Robert Ryman, and Richard Serra. This funding allowed for the in-depth analysis of damages to monochromatic paint films and modern sheet metal finishes. All living artists in the Panza Collection (or representatives from their estates) were interviewed regarding their personal approach to the preservation of their works and some larger philosophical issues surrounding conservation and alteration of artworks. These sessions were videotaped and are available for scholarly research. This endeavor led to the creation of the Guggenheim's innovative Variable Media Initiative, through which contemporary artists in the collection help determine future conservation of their work, which is often ephemeral in nature. The museum has organized numerous exhibitions featuring works from the Panza Collection, including *Singular Dimensions in Painting* (Guggenheim Museum SoHo, May 26, 1993–January 4, 1994), *Postmedia: Conceptual Photography in the Guggenheim Museum Collection* (February 18–May 7, 2000), *California Art from the Panza*

impressed by the mute poetry of these iconoclastic canvases, the composer John Cage wrote his famous *4'33"* (1952), an interval of absolute silence lasting as long as the title indicates. Rauschenberg's engagement with the flux of the environment in which the work was experienced and his recognition of the viewers' presence was enormously influential on a younger generation of sculptors and painters exploring art's materiality, its physical presence in the world, and its impact on perceptual processes. Along with the mechanical sensibility of Frank Stella's uniformly striped black paintings (begun in 1959), this work ushered in a decade of self-reflexive reductionism that came to be known as Minimalism.

During the 1960s a number of American artists—namely Andre, Flavin, Judd, LeWitt, and Morris, endeavored, albeit independently of one another, to create an art that excluded all compositional complexity (including figure/ground relationships), all surface incident, and all referentiality. Primarily sculptural, Minimal art is premised on the elementalism of geometric forms. It eschews the handmade in favor of anonymous, industrial production. It foregrounds its own essential objecthood rather than any symbolic valence. Seen in retrospect as the culmination and exhaustion of high Modernist values, which judged an artwork's validity by its adherence to the fundamental properties of its specific medium, Minimalism represents both an end and a beginning. It fulfilled Modernism's call for absolute self-reflexivity to a point of no return, paving the way for a younger generation of artists who would explore issues implicit in Minimalism's stripped-down aesthetic: an examination of the context in which art is encountered, an acknowledgement of the viewer's embodied state, and a revelation that art itself can function as a form of criticism.

Minimalism's immediate impact upon a slightly younger generation of artists is evident in the related and not-entirely subsequent emergence of a Post-Minimalist sensibility—a loosely defined aesthetic category, which signals a deliberate paucity of formal means utilized to explore a range of concerns including process, the dematerialization of the object, the performative nature of art, and the structural properties of light. Artist such as

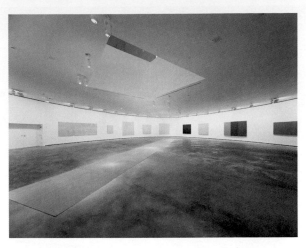

Jene Highstein, Robert Irwin, Richard Long, Nauman, Richard Serra, Turrell, and Doug Wheeler (to name those included in this exhibition) are among its diverse, international practitioners. While the inherent qualities of a chosen medium—be it Serra's molten lead, Turrell's projected or reflected light, Morris's industrial felt, or Long's physical journeys through uninhabited terrain—dictated the final structure of an artwork, the overall sensibility is one of extreme formal economy. With Post-Minimalism, the implicit phenomenological aspects of Minimalist sculpture—which necessitates the presence of a viewing subject to complete the work—become explicit. The perceiving body, physically present in time and space, became an integral component of Post-Minimalist art, which incorporated temporality and ephemerality into its vocabulary as a way to foreground the experiential nature of the aesthetic experience. With this as its focal point, the art object itself receded from its traditional, primary position, in some cases disappearing altogether, to be replaced by video or photographic documentation of an event or performance, mutable materials such as invisible gases or dirt, interventions in the landscape, or simply the passage of time as recorded by a shifting shadow.

Conceptualism, a concurrent and intricately linked artistic strategy, owes much of its self-reflexivity to Minimalism, in some cases due to a misreading of the movement

Collection at the Guggenheim Museum (Peggy Guggenheim Collection, Venice, September 2, 2000–January 7, 2001), and *Percepciones en transformación: La Colección Panza del Museo Guggenheim* (Guggenheim Museum Bilbao, October 10, 2000– March 22, 2001).

Above: *The Guggenheim Museum and the Art of This Century*, Guggenheim Museum Bilbao, October 19, 1997–June 1, 1998, installation view

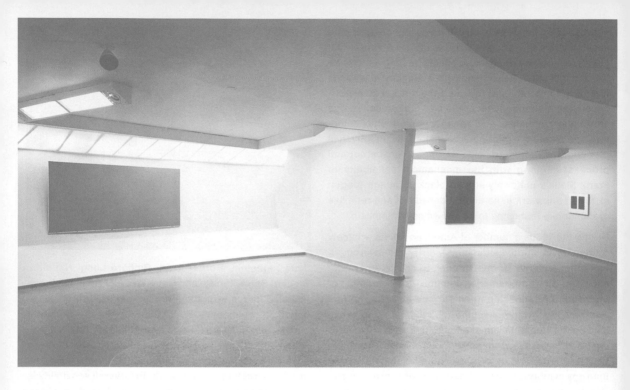

18

Brice Marden, March 7–April 27, 1975,
Solomon R. Guggenheim Museum,
New York, installation view

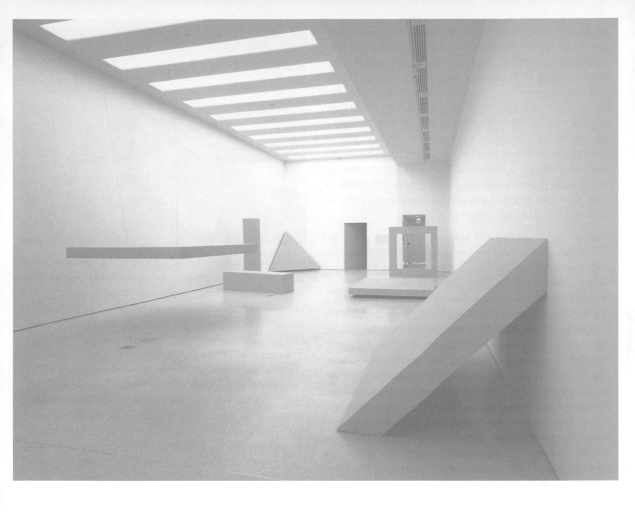

Robert Morris: The Mind/Body Problem,
February 3–April 17, 1994, Solomon R.
Guggenheim Museum, New York,
installation view

as purely ideational. While Minimalist sculpture and painting questioned the conventional parameters of art—pushing the limits of what constitutes an aesthetic object to a state of literalness, or pure objecthood—it did not, like Conceptualism, interrogate the ontological category of art itself. Nevertheless, key practitioners of Conceptual art, at least the text-based variant, including Kosuth, Art & Language, and Lawrence Weiner, shared in Minimalism's extreme reductionism. Eschewing the actual construction of objects in favor of written description, inquiry, and analysis, these artists extrapolated from the critical dimensions of Minimalism to create an essentially nonvisual art form.[2]

During the late 1970s and 1980s, many artists schooled in the deconstructivist tendencies of postmodernism resuscitated Minimalism as a style, infusing its unitary, nonreferential forms with content to bring to the fore trenchant cultural issues. During the mid-1980s, Peter Halley, Sherrie Levine, and Allan McCollum deliberately appropriated the look of Minimalist painting to critique how systems of power, consumption, and desire are embedded in and perpetrated by representational codes. For Levine—known for rephotographing classic fine-art photography, with examples ranging from Alexander Rodchenko to Walker Evans—the history of painting provided much fodder for her feminist critique of the supremacy of authorship. In her series of "Knot" paintings (begun 1985)—framed plywood panels on which the wooden knots are in-filled with white or gold or yellow pigment—Levine reduced the medium to its essential components: support and defining edge. These elegant statements of negation evoked at once medieval icons with their gold leaf elements, the uninflected planes of Minimalist painting, and the plywood constructions of Judd. With his *Surrogate Paintings* (1978–82) and *Plaster Surrogates* (begun in 1982), McCollum created representative "signs-for-a painting" that could be infinitely repeated, installed en-masse, and widely distributed in the market. Cast replicas of black-centered, matted, and framed pictures—in which the support and "image" are one-in-the-same and the content is nullified—the *Surrogates* ingeniously mimic the role of paintings in the

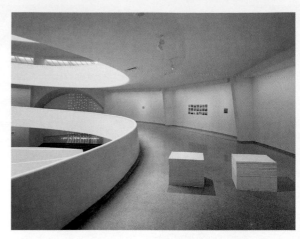

world: as collector's items, commodities, decorative embellishments, and objects of desire. Halley also invokes the formal attributes of Minimalist painting—rigid planes of color, unitary shapes, and nonhierarchical compositions—in his brightly hued canvases. Preferring the designation "diagrammatic" to "abstract" for his rigid formal arrangements, Halley conceives of his works as coded referents to the way in which geometry interacts with the social. His canvases acknowledge how, in late-capitalist culture, contemporary life has become increasingly inscribed by geometric networks: the urban grid, the office tower, the correctional institution, the shopping mall, the parking lot, and the like. By recasting the vocabulary of Minimalism to illustrate this social phenomenon, Halley has called the supposed neutrality of such art into question.

In a similar vein, Felix Gonzalez-Torres infused his work with a subtle, narrative sensibility. The obdurate Minimalist cube served as the formal source for his endlessly replaceable stacks of printed paper, which speak against social injustices such as homophobia and racism. And the Post-Minimalist "scatter art" of Serra and Morris (among others), was a referent for his candy spills—malleable piles of edible sweets, free for the taking—that symbolize the body, as both an inescapable mortal entity and a social force known as the "body politic." For Gonzalez-Torres, the art of the 1960s and 1970s had already entered the art-historical canon and

2 For an account of Conceptualism's misreading of Minimalism, see Hal Foster, "The Crux of Minimalism," in *The Return of the Real: The Avant-Garde at the End of the Century* (Cambridge: MIT Press, 1996). Originally published in Howard Singerman, ed., *Individuals: A Selected History of Contemporary Art 1945–1986*, exh. cat. (Los Angeles: Museum of Contemporary Art; New York: Abbeville Press, 1986), pp. 162–83. Of course, Conceptual art's "non-style," like all avant-garde movements, eventually became as commodifiable and collectible as the painting and sculpture it sought to critique and replace.

Above: *Felix Gonzalez-Torres*, March 3–May 10, 1995, Solomon R. Guggenheim Museum, New York, installation view

Facing page: *Guggenheim International Exhibition, 1971*, February 12–April 11, 1971, Solomon R. Guggenheim Museum, New York, installation view

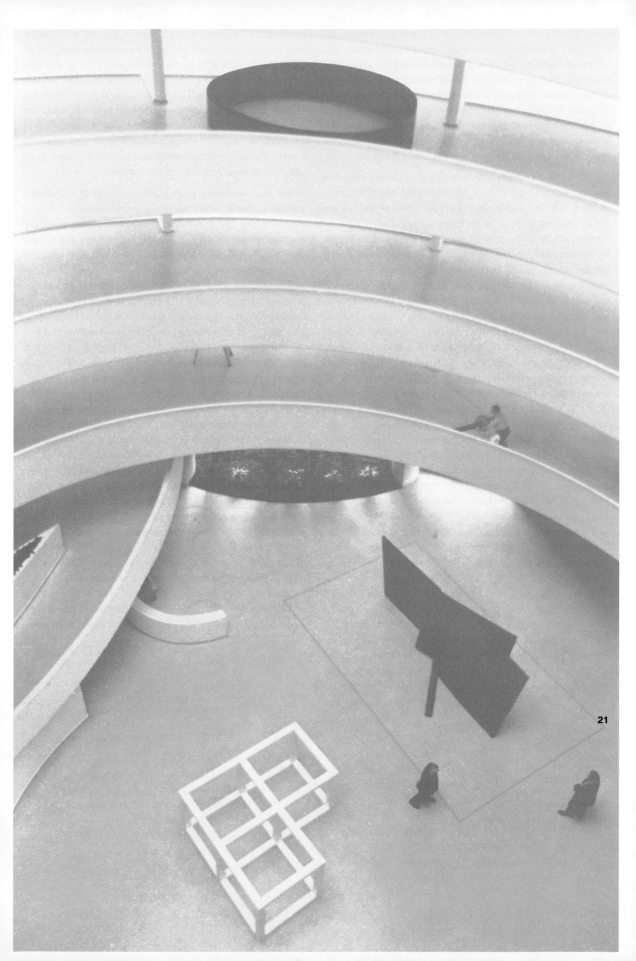

constituted new, classical forms of beauty. Flawless, industrially produced geometric sculptures; luminous, fluorescent light installations; simple declarative texts; and entropic, free-form objects constituted a new aesthetics of abstraction that was presumably devoid of content. By imbuing these forms with potentially incendiary subject matter dealing with a range of issues from AIDS and social reform to political satire, Gonzalez-Torres deliberately used this beauty as a form of contestation.

For many other artists active during the last two decades the reductive vocabulary codified during the 1960s provides a key departure point for their work, which can be viewed in some sense as individual homages to the radicalism of the original gesture. In his eccentric versions of the now-iconic geometric cube and his translucent tables, which function as pedestals for equally translucent objects, Charles Ray explores the structural formulae of Minimalist sculpture: the literalness of the aestheticized object, its contiguity of interior and exterior, and its articulation through repetition. But the effect of his work is achieved as much through a sleight of hand, a kind of brilliant illusionism, as it is through the simple rendering of volume and form. In a different vein, Robert Gober utilizes formal simplification to deeply poetic ends in his beautifully crafted, handwrought versions of industrial objects—ghostly, nonfunctioning sinks, a lone sheet of plywood, and a block of cast Styrofoam. By reconstituting banal objects found readily in the world, often juxtaposing them in evocative, surreal installations, Gober inverts the formal logic of high Minimalism, which relies on the suppression of the artist's hand as well as any narrative subtext. Roni Horn's "pair objects"—twinned, geometric sculptures, drawings, and photographs—explicitly activate memory and perception while invoking ideas about identity and difference. They exploit the principle of duplication in order to explore the concept of unity. Their twin components reveal themselves simultaneously *and* sequentially. Through their repetition of form, the "pair objects" embody a here and a there, a before and an after. They create a site marked by traversal and progression, requiring the viewer to move from one element to the other in a dialectical experience of part to whole. Meg Webster renders pure, geometric forms out of organic materials such as salt, peat moss, and branches to comment on the ever-increasing fragility of the world's eco-system. Wolfgang Laib works with the most elemental of materials—milk, marble, pollen, and beeswax—to craft pure, sculptural forms that bespeak rituals of growth and renewal. And Karin Sander produces nearly invisible interventions into the gallery environment by burnishing portions of its wall space to create monochromatic white forms that demand keen perceptual awareness to be witnessed.

While *Singular Forms (Sometimes Repeated)* is installed chronologically, with the "precursors" in the museum's High Gallery, the Minimalist, Post-Minimalist, and Conceptual artists on the middle ramps, and the contemporary work on the uppermost levels of the Rotunda, the exhibition begins out of sequence with Rachel Whiteread's *Untitled (One Hundred Spaces)* (1995), an installation of 100 colored resin cubes cast from the void underneath of an average chair. Located on the Rotunda floor, this vast, multicomponent sculpture perfectly embodies the themes of the exhibition. A repetitive sequence of singular forms differentiated only by hue and subtle inconsistencies caused by the casting process, this work has its formal roots in Minimalism but far transcends that movement's call for nonreferentiality. The work's individual translucent units oscillate between abstraction and figuration; they appear at once as mute, cubic forms and the indexical trace of empty space formerly delimited by the simple architecture of a chair. Collectively, these cubes constitute a field, a rainbow of like forms, which requires careful perceptual analysis to be fully appreciated. But, as in all of Whiteread's work there are explicit allusions to the empirical world, specifically to the domestic, which are simultaneously nostalgic and uncanny. As a whole, the exhibition should similarly alternate between pure abstraction and referentiality, moving fluidly between these two poles without any radical shifts in formal terms. *Singular Forms (Sometimes Repeated)* demonstrates that a cube is rarely just a cube, even when it claims to be.

Skinning Art

Mark C. Taylor

It is the happiness of eyes that have seen the sea of existence become calm, and now they can never weary of the surface and of the many hues of this tender, shuddering skin of the sea.
—Friedrich Nietzsche

If someone asked me, "What's your problem?" I'd have to say, "Skin."
—Andy Warhol

What you see is what you see.
—Frank Stella

How many ways are there to skin the work of art? In Minimalism, it seems, there was only one: Minimalists skinned art by stripping it down to the bare bones of primary or elemental form. These forms tended to be geometric and could, therefore, be clearly defined and precisely articulated. Not all Minimalist gestures, however, were the same. For some artists who can be described as Minimalists, the primal was precisely that which eludes structure and, thus, cannot be formalized. Throughout the 1950s and 1960s, different interpretations of the primary or primal led to different versions of "the reductivist impulse" characteristic of Minimalism. From the investigation of basic forms articulated in objects that purport to be nothing other than themselves to monochrome canvases and material works whose physical presence in the world reduces compositional complexity to the "presence" of elemental simplicity, artists sought what they believed to be rudimentary in the work of art as well as in experience. What unites these otherwise disparate tendencies is their sustained critique of representation and, correlatively, of the referentiality of the work of art. While representation and referentiality are not identical, they both presuppose that the work of art is related to something that transcends it. For Minimalism, by contrast, the work of art does not represent or refer to anything other than or different from itself, but is the thing itself. In different terms, the work of art is *autonomous*—that is, it is neither conditioned by nor directed toward anything else. Many Minimalists, influenced by the newly popular style of philosophical inquiry known as phenomenology, seemed to take up Husserl's call "*zu den Sachen*" (to the things).[1] Stripped of all referential or symbolic valence, the art object became *the thing itself*. The thing, however, was interpreted in a variety of ways, ranging from material presence or "objecthood" to concept or even information. This search for *the thing itself* was designed to overcome the mediation endemic to representation and referentiality by reducing depth to surface and interiority to exteriority and thereby creating direct intuition approximating immediacy. In the absence of depth and interiority, art becomes a "matter" of skin—or, in the memorable words of Dennis Potter's television series the *Singing Detective*, "skin rubbing against skin."[2] When it's skin all the way down and all the way in, "what you see is what you see." Minimalists attempting to explain their work might well have appropriated Andy Warhol's words: "If someone asked me, 'What's your problem?' I'd have to say, 'skin.'"[3]

Minimalism was the logical outworking of the notion of Modern art first articulated in the small German duchy of Jena during the last decade of the eighteenth century. Kant and the artists and philosophers who developed his insights defined the idea of art that governed artistic theory and practice throughout the twentieth century. Developments in art never take place in a vacuum, however, but are always inseparably related to broader social, political, cultural, and, perhaps most important, economic currents. Just as Kant's definition of art arose at the precise moment when significant economic changes were occurring in Europe, so Minimalism was bound to fundamental changes in capitalism during the middle decades of the twentieth century. As art was becoming more self-reflexive, capital was becoming more self-referential; money went from being a precious substance (gold and silver coins) to being a sign of a material referent (paper currency backed by gold and silver), then an ungrounded sign (paper currency without silver or gold backing), and finally, with digital and virtual capital, a mere concept or idea. In other words, money, like art, underwent a process of gradual dematerialization until both became nothing more than a concept or, more accurately, information. The movement from Pop art through Minimalism to Conceptualism both anticipated and was influenced by the transition from industrial and consumer capitalism to digital and finance capitalism. By tracing this trajectory, it becomes clear that there is more than one way to skin the work of art.[4]

Twentieth-century art effectively began with the publication of Kant's *Critique of Judgment*. Kant's overall philosophical project is devoted to the three classical problems in the history of Western philosophy: truth (*Critique of Pure Reason*, 1781), goodness (*Critique of Practical Reason*, 1788), and beauty (*Critique of Judgment*, 1790). What unites the three critiques is Kant's interpretation of the principle of autonomy. "Autonomy," which derives

26

1 While the roots of phenomenology can be traced to Hegel's *Phenomenology of Spirit* (1807), it was Husserl who set the terms for debates about phenomenology in the early decades of the twentieth century. According to Husserl, the thing itself is an *eidos*, or essence, which can be directly intuited by stripping away or "bracketing" the existence of the actual material object. This intellectual intuition presupposes what Husserl describes as the phenomenological reduction (the *epoche*), which requires the investigator to set aside all of his or her assumptions.

2 For an exploration of the multiple nuances of "skin" in the context of Potter's television series, see the first chapter of my book *Hiding* (Chicago: University of Chicago Press, 1997).

3 Andy Warhol, *The Philosophy of Andy Warhol* (New York: Harcourt Brace, 1975), p. 8.

4 "Skin" is a word whose multiple meanings unleash seemingly endless associations. "Skin" means both to cover with skin or to cause skin to grow, and to strip, remove, or peel off skin. Several meanings of "skin" are related to money. In slang, it refers to billfold money as well as to a purse, money bag, or pocketbook. In gambling, to "skin" a person is to strip him or her of all his or her money. This meaning is also suggested by the word "fleece." A "skin game" is a game of chance in which

from *autonomos* (*auto*, self + *nomos*, law), means self-regulation or self-determination. According to Kant, the principle of autonomy functions differently in each of our three faculties: pure reason is autonomous when it determines itself through a priori forms of intuition and categories of understanding; practical reason (the will) is autonomous when the ethical agent freely gives himself or herself the universal moral law; and aesthetic judgment is autonomous when it is free of external influence and thus remains disinterested. In *Critique of Judgment*, Kant articulates the principle of autonomy in terms of what he describes as "inner teleology" or "purposiveness without purpose." In contrast to external teleology, in which ends are either imposed from without or externally directed, in inner teleology, means and ends are reciprocally related in such a way that each arises in and through the other. Kant repeatedly explains the distinction between external and internal teleology in terms of two important contrasts: first, the difference between utility and nonutility, and second, the difference between mechanisms on the one hand and natural organisms and beautiful works of art on the other. Kant's interpretation of the beautiful work of art was crucial for the emerging distinction between so-called high (or fine) art and low art. While low art, according to Kant, is utilitarian, high art is nonutilitarian; low art is made to sell for profit, whereas high art is created for its own sake and, thus, has no practical value; the end or purpose of low art is external (the market), and the end of high art is internal (art).[5] When understood in terms of the distinction between mechanism and organism, the beautiful work of art is, like the organism, a "*self-organized being*": in both, order is not imposed from without but emerges within through a complex interplay of parts, which, in the final analysis, constitutes the activity of the whole. "The parts of the thing," Kant argues, "combine of themselves into the unity of the whole by being reciprocally cause and effect of their form. For this is the only way in which it is possible that the idea of the whole may conversely, or reciprocally, determine, in its turn, the form and combination of the parts."[6] This reciprocal relation of means and ends constitutes a self-reflexive structure, which points to nothing beyond itself and is, therefore, self-referential. For

Kant and his followers, fine art is, by definition, self-referential. This notion of the autonomy of art has remained influential for art criticism and artistic practice through the twentieth century and down to the present day.

Kant places severe epistemological strictures on the self-reflexive idea he defines. Since we cannot know reality as such—or, in Kant's terms, the thing-in-itself—we can never be sure whether the notions of autonomy, inner teleology, and self-referentiality tell us anything about the way things really are. Though the truth of the notion of intrinsic purpose remains uncertain, it nonetheless can serve as a regulative idea or heuristic device to order thoughts and guide experience. Hegel, who appropriated Kant's account of inner teleology and transformed it to create the dialectical structure of his entire system, argues that the structure of self-reflexivity is not merely a useful regulative idea but constitutes the logical organization of reality itself; the self-reflexive Idea, in other words, is the primary form of all reality. Neither static nor fixed, this logical structure is dynamic and unfolds through a dialectical process, which Hegel charts in his monumental *Science of Logic* (1812–16). "*The Concept is everything*," he argues, "and its movement is the universal absolute activity, the self-determining and self-realizing movement."[7] Hegel maintains that his philosophical system brings the truth first expressed in religious and artistic *representations* to *conceptual* clarity. Indeed, he claims that the task of philosophy is to translate representations (*Vorstellungen*) into concepts (*Begriffe*). While representations are supposed to refer to something beyond themselves (the word "tree," for example, points to the existing tree), concepts are thoroughly self-reflexive (the concept articulates the rational form that constitutes the essence of the thing itself). Insofar as "the concept is everything," there is nothing outside the Idea—that is, there is nothing outside the self-referential structure that constitutes the logical structure of thought as well as reality. Within this autonomous structure, every trace of transcendent referents, which might appear to render concepts meaningful, disappears. Such referents are not limited to seemingly independent things or entities but can also include the transcendent God, the interiority of the expressive subject,

the player has no chance of winning. Finally, a "skinflint" is a cheapskate.

5 One of the primary reasons the distinction between high and low art emerged at this historical moment is that the patronage system had broken down to such an extent that artists had to find a way to support themselves. Many artists were forced to create work to sell on the rapidly developing art market. Art produced for sale, many insisted, was not true art. Clement Greenberg's analysis of kitsch is nothing more than an extension of Kant's argument to later forms of production and reproduction.

6 Immanuel Kant, *Critique of Judgment*, trans. James Meredith (New York: Oxford University Press, 1973), Part II, p. 21.

7 G.W.F. Hegel, *Science of Logic*, trans. A.V. Miller (New York: Humanities Press, 1967), p. 826. Hegel's use of the words concept (*Begriff*) and Idea (*Idee*) is sometimes confusing. *Concept* designates the Idea in its incomplete form. The fully deployed Idea consists of the dialectical interrelation of the concepts in and through which the Idea itself emerges. When understood in this way, the Idea defines the rational structure of thought as well as being.

or any dimension of depth that is purported to ground surfaces. In Hegel's scheme, the concept *sensu strictissimo* is always the concept of a concept and the Idea is always the Idea of an idea. Hegel's dialectical system brought about a *structural revolution*, which can best be described as a seismic shift from a referential to a relational or, more accurately, *differential* notion of meaning and value. For Hegel, the meaning and value of a concept are not the results of the concept's reference to independent things or situations but are a function of the concept's differences from and hence relations to other concepts. It is, of course, important to stress that in Hegel's absolute idealism, things are essentially concepts whose interrelation forms the all-encompassing Idea.

The intricacies of Hegel's system harbor implications whose significance for art during the last half of the twentieth century are not immediately evident. One hundred years after the publication of Hegel's *Science of Logic*, Ferdinand de Saussure laid the foundation for what would eventually be labeled "the structuralist revolution" by developing an innovative interpretation of language. In the best-known line in his influential *Course in General Linguistics* (1916), Saussure states that in the system of language, "there are only differences with no positive terms." For Saussure, the differential nature of signs means that a sign never points beyond itself to an antecedent concept or independent idea; within the structure of the sign, the signifier refers to a signified, which itself is formed by its place within the differential system of signs. Just as Hegel's self-referential Idea exposes every concept of a thing to be a concept of a concept, so Saussure's notion of language translates every apparently transcendental signified into a signifier of another signifier.

Three consequences of Saussure's analysis are important in this context. First, signifiers do not refer to preexisting things or concepts but derive meaning from the differential network within which they are inscribed. Second, the play of signs is self-reflexive and self-referential: signs are always signs of signs. Finally, in a manner reminiscent of Hegel, Saussure reverses the modern philosophy of creative or expressive subjectivity by suggesting what philosophers and critics would later describe as the "decentering," "dissolution," "deconstruction," or even "death" of the subject: instead of constituting language, the speaking subject is actually formed by its place within the publicly available linguistic system. The subject, in other words, is a function of the system rather than the system being a function of the creative subject.

By the middle of the twentieth century, the ideas articulated in Kant's critical philosophy, Hegel's speculative philosophy, and Saussure's structural linguistics were not only informing aesthetic theory and artistic practice but, more unexpectedly, were being concretely realized in the transformations of postwar capitalism. Citing Kant, Clement Greenberg declared: "The essence of Modernism lies, as I see it, in the use of characteristic methods of a discipline to criticize the discipline itself, not in order to subvert it but in order to entrench it more firmly in its area of competence."[8] From this point of view, Modern art is self-critical and, thus, reflexive or self-referential; art, as Kant and Hegel anticipated, is about art—instead of representing the world or anything else, it refers to itself. Using this understanding, Greenberg proceeded to construct a teleological narrative of art history, in which, from its earliest beginnings, art steadily moves toward increasing abstraction and greater formalism. While Greenberg championed Abstraction Expression, the trajectory he charted actually pointed toward the progressive movement from Pop art through Minimalism to Conceptualism.

In a 1963 interview with G. R. Swenson, Warhol provocatively announced: "I think everybody should be a machine. I think everybody should be like everybody."[9] The machine Warhol became was a hybrid of the industrial machines of postwar America and the emerging media machines of consumer capitalism. The transition from industrial to consumer capitalism, which Warhol simultaneously embodied and promoted, was an economic necessity. In the years immediately following World War II, industrial production in the United States had soared to meet previously pent-up demand. With markets quickly reaching saturation, the challenge had become to create desire where there was no need. The

28

8 Clement Greenberg, "Modernist Painting," in Greenberg, *The Collected Essays and Criticism*, vol. 4: *Modernism with a Vengeance, 1957–1969*, ed. John O'Brian (Chicago: University of Chicago Press, 1993), p. 85.

9 G. R. Swenson, "What Is Pop Art? Answers from Eight Painters," *Art News* 62 (November 1963), p. 26.

most obvious way to do this was through the acceleration of product cycles and aggressive advertising campaigns. As advertising extended beyond print into electronic media, products increasingly disappeared into their images. The object of desire became an image more than a thing; when a consumer purchased a car he didn't really need, for example, he was buying into the image of the car and the life it promised. Warhol was one of the first to recognize the relationship between these economic developments and contradictions in Greenbergian Modernism. In the late 1940s and 1950s, Greenberg's campaign on behalf of select American artists had combined with the rapid expansion of the New York gallery system to draw so-called high art into the very market system from which Greenberg's critical theory attempted to isolate it. As the postwar economic boom raised the standard of living for the American middle class and social distinctions became harder to draw, many intellectuals and "leftists" formed an unexpected alliance with the upper class by turning to the works of the artistic avant-garde for cultural markers that would set them apart from the supposedly unsophisticated masses. Advertisements placed by galleries in fashionable publications like *Partisan Review* transformed high art into an unmistakable sign of a particular lifestyle.

Warhol embraced these developments with unbridled enthusiasm and characteristically upped the ante: he not only turned art into advertising but also made advertising art. Withdrawing his hand from the creative process, Warhol became the manager of a production machine that turned out works almost as anonymous as the images circulating in the rapidly proliferating media. In the Factory, mechanical reproduction was not a technique to be avoided but was the preferred procedure for producing series after series of formulaic works. Warhol went so far as to declare that he believed anyone should be able to do his paintings for him. As images of Campbell's soup cans and Brillo boxes rolled off the assembly line and screened images quickly flashed by like flickering faces and scenes on a television screen, the difference between art and non-art became obscure. Though Warhol's works are figurative, they are not representational. More precisely, his paintings, silkscreens, and sculptures

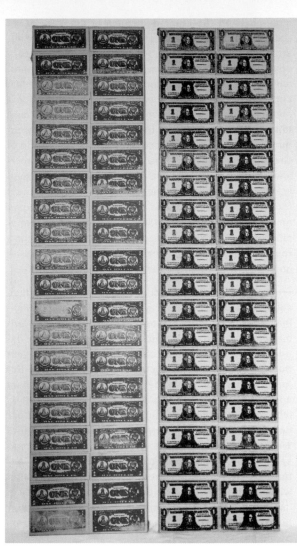

refer to images of other images and signs of other signs and, thus, lack both depth and interiority. This is what Warhol meant when he said that his overriding concern was skin: skin rubbing against skin. Peel away one layer and another layer appears.

As might be expected, many artists saw Warhol's apparent embrace of consumer culture as the betrayal of Modernism's mission, and some of the most effective

Above: Andy Warhol
Front and Back Dollar Bills, 1962
Synthetic polymer paint and silkscreen
ink on canvas two panels, each 83 x 19
inches (210.8 x 48.3 cm)
Formerly of the artist's estate

challenges to the commodification of the work of art grew out of radicalizations of Greenberg's doctrine of abstraction. As if translating Hegel's speculative philosophy into an artistic program, Minimalism and Conceptualism progressively dematerialized the work of art until it became a concept or an idea. When pushed to the limit, abstract art negates representational and symbolic content and concentrates on formal structures and procedures. Leo Steinberg identified the logical conclusion of Greenberg's doctrine: "How often recent abstract American painting is defined and described almost exclusively in terms of internal problem-solving. . . . The dominant formalist critics today tend to treat modern painting as an evolving technology wherein at any one moment specific tasks require solution. . . . The artist as engineer and research technician becomes important insofar as he comes up with solutions to the right problems."[10]

From one point of view, Warhol and his fellow Pop artists seem to have skinned art very differently from the Minimalists, who stripped it down to the bare bones of primary forms. Nothing would seem farther from the pristine forms and figureless canvases of Minimalism than the riot of images and signs in Pop art. But these differences are deceptive, because Pop and Minimalism agreed about the all-important issue of the self-reflexivity and hence nonreferentiality of the work of art. Indeed, Frank Stella might well have been talking about Warhol when he claimed: "What you see is what you see."[11] Minimalism shared Warhol's desire to erase every trace of creative expression in a machinic production without either interiority or depth: the work refers only to itself, and depth and interiority disappear in a play of surfaces. In their absence, meaning, as Rosalind Krauss explains, is

> a function of surface—of the external, public space that is in no way a signifier of the contents of a psychologically private space. . . . The ambition of Minimalism was, then, to relocate the origins of a sculpture's meaning to the outside, no longer modeling its structure on the privacy of psychological space but on the public, conventional nature of what might be called cultural

space. To this end the Minimalists employed a host of compositional strategies. One of these was to use conventional systems of ordering to determine composition. As with Stella's use of conventional signs, these systems resist being interpreted as something that wells up from within the personality of the sculptor and, by extension, from within the body of the sculptural form. Instead, the ordering system is recognized as coming from outside the work.[12]

Stella's position had different implications for artistic production. Insofar as the locus of meaning shifted from the creative individual to conventional systems of signs that were, in some ways, "external" to the artist, the subject was displaced and the network of signs decentered. When understood in this way, Minimalism put into practice the theory of structural linguistics, which, at the time, was being appropriated by literary critics, anthropologists, psychologists, and political theorists. The "conventional nature of what might be called cultural space" is, in effect, what Saussure calls language (la langue) and Jacques Lacan labels the symbolic order, where meaning is conferred by the differential play of signs, which simultaneously surpass and encompass particular signifiers and individual agents. Rather than the creative artist being the origin of the work of art, the artist and the work were functions of the structural networks within which they were inscribed.

Stella's accounts of his own work were not always consistent with the premises and conclusions of Minimalism, however, but actually anticipated Conceptualism. For example, Stella deliberately planned his work before he began and then proceeded methodically to execute his program. "The painting," he explained, "never changes once I've started to paint on it. I work things out beforehand in the sketches."[13] For Stella, the act of creation was the formulation of the idea of the work rather than its material production. The ideational or conceptual character of the work of art complicated the problem of representation. On the one hand, if the work of art is a nonreferential object in which "what you see is what you see," it would seem that the representation and

10 Quoted in David W. Galenson, *Painting Outside the Lines: Patterns of Creativity in Modern Art* (Cambridge, England: Cambridge University Press, 2001), p. 131.

11 Quoted in Gregory Battcock, ed., *Minimal Art: A Critical Anthology* (Berkeley: University of California Press, 1969), p. 158.

12 Rosalind Krauss, *Passages in Modern Sculpture* (Cambridge: MIT Press, 1993), pp. 266, 270.

13 Quoted in Galenson, *Painting Outside the Lines*, p. 136.

14 Ibid.

15 *Sol LeWitt: Critical Texts*, ed. Adachiara Zevi (Rome: Editrice Inonia, 1994), p. 123.

16 Ibid., p. 32.

17 For a more detailed consideration of these points, see my *Confidence Games: Money and Markets in a World Without Redemption* (Chicago: University of Chicago Press, forthcoming).

18 Personal correspondence from the artist, November 8, 2003. In the catalogue accompanying the 1994 retrospective of Morris's work at the Guggenheim Museum, Kimberley Paice points out that this work recalls "Duchamp's production of bonds for investing in a system to win at roulette at the Monte Carlo Casino and to his *Tzanck Check* (1919), an artwork that

what it represents are identical. On the other hand, Stella claimed: "I do think that a good pictorial idea is worth more than a lot of manual dexterity."[14] From this perspective, the painting appears to represent the idea in a way that presupposes oppositions between concept/work, creation/production, conception/execution, and form/matter. Throughout the history of Western metaphysics, such binary oppositions have always been hierarchical. For Stella, like his philosophical and theological precursors, the former term in each dyad was privileged over the latter. The concept was essential, its material appearance accidental.

In the 1960s, Conceptual artists extended Stella's argument by pushing abstraction to its *logical* conclusion. "I wasn't really that interested in objects," Sol LeWitt has confessed. "I was interested in ideas."[15] The separation of the conception and production of the work of art was not, of course, new. For centuries, students and assistants of painters and sculptors had produced works bearing their master's name. What was new was Conceptual art's subordination of object to idea: "In Conceptual art the idea or concept is the most important aspect of the work. When an artist uses a conceptual form of art, it means that all the planning and decisions are made beforehand and the execution is a perfunctory affair. The idea becomes a machine that makes the art."[16] This comment by LeWitt, made in 1967, has proven to be even more seminal than he could have imagined. During the late 1950s and early 1960s, the machines artists imagined had been industrial; by the end of the 1960s, however, information-processing machines were beginning to appear. When the idea producing the work became a program, art was poised to enter the information age. The transition from Minimalism to Conceptualism was inseparable from the shift from industrial and consumer capitalism to digital and finance capitalism. By the late 1960s, money, as well as art, was becoming a "matter" of floating signs and circulating information.[17]

Nothing would seem farther from Warhol's embrace of the commodification of art and promotion of consumer capitalism than the machinations of Conceptual art. While Warhol skinned art by layering the images circu-

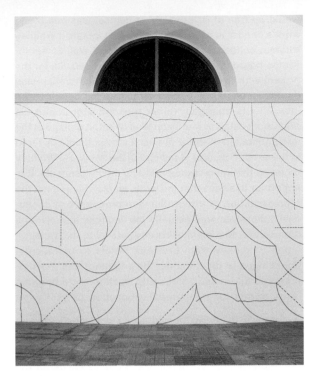

lating through the media in consumer capitalism, Minimalists skinned art by stripping away all figuration to expose primary forms—and if these primary forms are, in effect, coded information, Minimalism, in this sense, becomes indistinguishable from Conceptualism. In ways that are not immediately obvious, Conceptualism prefigured the shift to finance capitalism and a network economy that has taken place over the last four decades.

Robert Morris was one of the first artists to recognize the importance of these developments. His work *Money*, which appeared in *Anti-Illusion: Procedures/Materials*, an exhibition at the Whitney Museum of American Art in New York in 1969, "involved borrowing money from the Whitney Museum and investing it for the period of time of the exhibition." He explains, "The original proposal was to borrow $100,000 and invest it in art, which I intended to sell and to split the profit with the Whitney."[18] The trustees of the Whitney would not approve the proposal unless Morris guaranteed that the investment

Duchamp issued as payment for a dental bill." (*Robert Morris: The Mind/Body Problem*, exh. cat. [New York: Guggenheim Museum, 1994], p. 116.) Morris's work seems all the more prescient when one realizes that 1969 was also the year when Reuters installed the first electronic system for currency trading.

Above: Sol LeWitt
Wall Drawing #146
All two-part combinations of blue arcs from corners and sides and blue straight, not straight, and broken lines. September 1972. Blue crayon; dimensions vary with installation. Solomom R. Guggenheim Museum, New York. Panza Collection, Gift. 92.4160

would be free of risk (which, of course, was one of the work's central issues). When Howard Lipman, a Whitney trustee, collector of Morris's work, and Wall Street investor, heard about the impasse, he lent $50,000 for the project with the caveat that he be allowed to supervise the investments. With this new player, the nature of the investments changed: rather than art, Morris and his partner invested in bonds on Wall Street. A collage of the documentation of these financial transactions appeared in the exhibition, and at the end of the show, the Whitney received the interest generated by the investments. It is important to stress that the work, for Morris, was not the representation of the products or processes of consumer culture but was actually the financial transactions themselves. In a manner strictly parallel to the transmutation of money from precious metals to representational signs to digital code, the art object was transfigured into information that could function like a program or algorithm for its material production or exchange.

Just as artists during the middle of the twentieth century responded to Hegel's challenge of translating artistic images and representations into concepts, so the *speculative* financial markets of the past two decades mirror the *speculative* philosophy Hegel outlined in his *Phenomenology of Spirit* (1807). By the early 1980s, the financial economy was driving the so-called real economy. While buying and selling things (commodities) did not, of course, cease, financial products, which are signs of signs or, more precisely, information about information, became increasingly important for the global economy. Though claiming to be a science, economics is an art in more than a trivial sense.[19] When investors play with signs that refer to other signs and artists create works that are financial transactions, the circle circumscribing the work of art appears to be complete, bringing to a close the trajectory that began in post-Kantian art and philosophy. The question is whether gaps remain in which new departures in art as well as finance can emerge. To answer this question, it is important to note that skin not only layers and peels but also folds and refolds in ways that make the relation between surface and depth or exteriority and interiority irreducibly complex (*com*, together + *plectere*, to twine, braid). To trace these

folds, it is necessary to recall that there was an alternative phenomenology that was equally or perhaps even more important for many artists in the 1950s and 1960s: Maurice Merleau-Ponty's *Phenomenology of Perception* (1945). While Merleau-Ponty agrees with Hegel and Husserl's insistence that the task of phenomenology is to lay bare the structures of consciousness and self-consciousness, he insists that self-reflexivity can never be complete. Reflection, he argues, cannot itself grasp its full significance unless it refers to the *unreflective* fund of experience, which it presupposes and upon which it draws. This resource, which is perceptually apprehensible but conceptually ungraspable, constitutes something like "an original past, a past, which has never been present."[20] As a result of this "original past," the self-conscious subject (the eye/I) can never turn around fast enough to see itself seeing; vision and knowledge have blind spots and, therefore, are always incomplete. In his book bearing the richly suggestive title *The Visible and the Invisible* (1964), Merleau-Ponty uses a bodily image to explain the inevitable incompleteness of consciousness and self-consciousness:

> My left hand is always on the verge of touching
> my right hand touching the things, but I never reach
> co-incidence; the coincidence eclipses itself
> at the moment of producing itself, and one of two
> things always occurs: either my right hand really
> passes over to the rank of touched, but then
> its hold on the world is interrupted; or it retains its
> hold on the world, but then I do not really touch *it*—
> my right hand touching, I palpate with my left hand
> only its exterior envelope. . . . But this incessant
> withdrawal or concealment, this impotence to
> superpose exactly upon one another the touching
> of the things by my right hand and the touching
> of this same right hand by my left hand . . . is not
> a failure.[21]

Like skin folding back on itself, every self-referential structure has wrinkles that cannot be smoothed out. The gap between touching and touched, seeing and seen, subject and object implies a delay that marks the space of time. With the recovery of the bodily bias of percep-

19 No one has understood these developments better than Thomas Krens, Director of the Guggenheim Museum. There is no doubt that Krens's long-standing interest in Minimalism is inseparable from his sophisticated understanding of speculative financial markets. It would, therefore, seem to be no accident that *Singular Forms* is appearing at the Guggenheim Museum at

the precise moment when the programs and models that created both the booming financial markets of the 1990s as well as its collapse are undergoing critical reassessment.

20 Maurice Merleau-Ponty, *Phenomenology of Perception*, trans. Colin Smith (London: Routledge and Kegan Paul, 1978), p. 242.

21 Maurice Merleau-Ponty, *The Visible and the Invisible*, trans. Alphonso Lingis (Evanston, Ill.: Northwestern University Press, 1968), pp. 194–95.

tual awareness, time inevitably insinuates itself into the work of art. Primary forms are no longer primal because they necessarily imply something they can neither articulate nor formalize. As Post-Structuralists have shown, purportedly primary forms are always faulty because they presuppose as a condition of their possibility something they can neither include nor incorporate. This lingering gap can only be rendered at the point when and where the structure seems to be complete; in Minimalism and Conceptualism, it was simultaneously erased and exposed. By inadvertently revealing the impossibility of the completion of the Modernist project, Minimalism and Conceptualism created the time and space for the emergence of new strategies and styles. During the past two decades, the world of art has been as turbulent and unpredictable as the financial markets that fuel it. What we know that Modernists did not is that the complications of skin can never be simplified: skin *always* has holes. There is no end to art because the gap in which it emerges can never be closed.

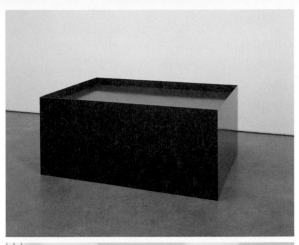

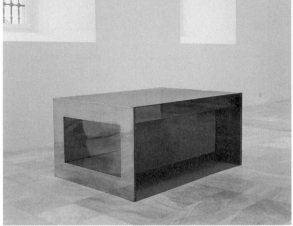

Above: Donald Judd
Untitled, 1968
Enamel on aluminum
22 x 50 x 37 inches (56 x 127 x 94 cm)
Solomon R. Guggenheim Museum, New York. Panza Collection, Gift. 91.3711

Below: Donald Judd
Untitled, May 21, 1973
Brass and blue Plexiglas
33 x 68 x 48 inches
(83.82 x 172.7 121.9 cm)
Solomom R. Guggenheim Museum, New York. Panza Collection 91.3721

The Pursuit of Simplicity:
Recent Architectural Minimalism
Deyan Sudjic

"Minimum is the ultimate ornament," writes a belligerent Rem Koolhaas in "Junkspace," "a self-righteous crime, the contemporary baroque. Minimum is maximum in drag. It does not signify beauty but guilt."[1]

This is a not altogether unsurprising position for the sharpest architectural controversialist of his generation to take, and one that was graphically demonstrated in his recent exhibition in Berlin. Splashed across the bronze-and-glass facade of Berlin's Nationalgalerie was the title of the show, *Content*, applied on a plastic film, dripping simulated spatters of yellow paint, as if in reproach to the void at the heart of Ludwig Mies van der Rohe's sublime building. Inside, past a T-shirt stall and the usual random burst of statistics, visitors came across a doll-sized effigy of Koolhaas, impaled on a steel rod, emerging from the midst of a pile of discarded crumpled blueprints and broken models. The doll's miniature black shirt and charcoal-gray striped trousers, just like Koolhaas's, were clearly from Prada, for whom Koolhaas has designed stores. A digital projection of the architect's face played over the doll's blank white head. If you listened carefully, you could catch snatches of Koolhaas reading selected passages from "Junkspace."

Koolhaas's worldview suggests that reality is so dismal and so bleak that the only way to blot out the pain of existence is by embracing it in all its unbearable, meaningless banality. To struggle against it is to be continually reminded of the painful reality; to submit is to avoid the agony. Minimal, or perhaps Minimalist, architecture—if there is such a thing—might best be understood as the exact opposite of Koolhaas's despair. It is the most recent manifestation of the continual search to find ways in which to use our ability to manipulate space and structure in order to bring some sense of meaning to the chaotic shapelessness of everyday life. When we can have no confidence that there will actually be a future at all, when we must confront the possibility that we are meaningless specks of matter in an equally meaningless universe, an architecture that seems capable of offering at least the sensation, or the appearance, of meaning within this blank void offers a certain solace. It is to believe that in the midst of manifest chaos, the human

intellect is capable of constructing at least a fragment of reality free of internal contradictions, a fragment that on its own terms seems to make sense, to demonstrate that logic and reason are not entirely illusions. It is to suggest that the contemplation of space, if sufficiently intense, can reveal levels of meaning about the nature of existence. This does not need to involve the semimystical poetics of Louis Kahn. It can simply take the form of a pragmatic exploration of what is required to cleanse space of visual distractions and thus make its occupation more fulfilling than it would otherwise be. It is to believe that mass, light, structure, containment, order,

1 Rem Koolhaas, "Junkspace," in Koolhaas, et al., *The Harvard Design School Guide to Shopping* (Cologne: Taschen; Cambridge: Harvard Design School, 2001).

Above: Gabellini Associates
Olympic Tower Residence, Bedroom Area
with view of bathroom (top), and Living
Area, New York, 2003

repetition, and volume are authentic phenomena, and that they provide the basis for linking ourselves to the natural world and making our mark within it. It is to understand that the position of a wall, the junction it makes with a floor, and the location of an opening within it can have an impact on our sense of well-being. It is to believe that intelligence can guide design. It is to construct an intellectual system that posits problems and offers methods of solving them. Which, of course, is the nature of all architecture.

It is a fundamentally optimistic position, one that runs counter to the belief that we are at the mercy of the randomness of events. But this is not to suggest that it is blithely optimistic. Alvaro Siza and Peter Zumthor, for instance, bring an austere, somber silence to architecture. Their work is a distant reflection of the most fundamental of architectural impulses, to make a mark on the landscape, manifested by the earth platforms of the earliest cities that seemed to offer a reference point and a step to making sense in a baffling universe, by stone circles and by artificial mounds. Later, the pyramids—and in our own times, the skyscraper—fulfilled the same role. Those early gestures reflect a continuing strand in the development of architecture, and the interconnection between perceptions of simplicity, moral force, and beauty that is constantly restated, most recently in the form of the doctrine of functionalism. Certainly, Mies van der Rohe's Farnsworth House (1946–51) can be seen as embodying these fundamental ideas. And, as such, what is now described as Minimalist architecture is simply a restatement of a recurring architectural theme.

Or perhaps it is more accurate to say recurring architectural *themes*, for there are alternative readings of Minimalism in architecture. In Japan, the concept of *wabi* reflects the idea of "voluntary poverty." But in many cultures simplicity and restraint have always been associated with patrician understatement and thus suggest a continuing connection with luxury that takes us, by way of Adolf Loos and his shop in Vienna for Knize, suppliers of Mies van der Rohe's immaculately tailored suits, to the strip of Madison Avenue stretching north from the neoclassical bank on the corner of East Sixtieth Street that

John Pawson transformed into a store for Calvin Klein in 1996, where for a while each new fashion store appeared to be whiter, emptier, and simpler, with more Portuguese limestone on the floor than the last. And there are other streets in the world that feel very much the same, from via Monte Napoleone in Milan to Bond Street in London, where Claudio Silvestrin's Giorgio Armani outlets rub shoulders with Michael Gabellini's Jil Sander store and David Chipperfield's for Dolce & Gabbana.

But the rich are as much in need of spiritual consolation as the poor. Calvin Klein may not have given away all his possessions to live like an ascetic, but that does not mean he is incapable of appreciating the aesthetic and philosophical qualities of simplicity. And there is certainly a spiritual aspect to simplicity. Cistercian monasteries historically enforced an architectural policy of simplicity and restraint both to provide their communities with a distinctive identity and to remind their members of the self-denial that their vows entailed and to make those vows easier to live up to. With curious symmetry, Pawson is currently engaged in the construction of the first Cistercian monastery in the Czech Republic since at least 1939 and Klein has designed the vestments for the community. In Japanese society, an appreciation of simplicity has been cultivated in its tea ceremonies and its aristocratic palaces, as well as in its Zen monasteries. In very different circumstances, the Shakers also found spiritual value in a cult of the simple. The spiritual is certainly present in the work of the architect Hans van der Laan, who was himself a monk and whose designs were confined to religious buildings of power and intensity.

There is also a clear idea about time, and the urge to resist its passing, expressed in the pursuit of simplicity. It is there, revealed in all its tragic vulnerability, in the work of Dieter Rams, the gifted postwar industrial designer. Rams has dedicated his career to reducing design to its essential minimum, to removing the unnecessary clutter of visual noise in the hope of creating a sense of permanence, to decouple the tools of our everyday lives from the idea of fashion. Thus, he has devoted years to the consideration of the most appropriate button on a control panel, the exact radius on the corner of an amplifier.

It is an activity that he has done brilliantly well, and his work for Braun has haunted the imagination of Richard Hamilton and other artists. He made the perfect calculator, from which nothing more could be removed without compromising its performance. He did the same for Braun's stereo system, as well as for its television sets. And yet, at a deeper level, he failed. He made perfect, timeless objects beyond fashion and applied decoration, but entire categories of objects he devoted his life to have become redundant. Who needs a calculator the size of a book anymore, when the function can be performed by a cell phone? The LP record is no longer the primary means for disseminating music, and its player is now three generations of technology out of date. Rams's designs for Braun are revealed as an impossible, Canute-like campaign against change that, in retrospect, was a beautiful failure.

The term "Minimal" first began to be applied to architecture twenty years ago in connection with Pawson, who emerged as an architect at the beginning of the 1980s. In contrast to the architectural landscape of the time—dominated by a last decorative flourish of pastel postmodernism before it vanished into Disneyland resort hotels, the high-water mark of militant neoclassicism led by the Prince of Wales, and its counterpoint, the muscular high tech of the British school that could verge on fetishism—what was called "Minimalist architecture" seemed like something entirely different. Certainly, it was fresh, but it wasn't new, and it probably didn't have much to do with Minimalism in the sense that it was understood at the time. The term has perhaps served only to confuse the issue.

Pawson designed a first apartment for himself that owed a debt to the much admired Japanese designer Shiro Kuramata, in the form of a pink finish on the cornice—Pawson's only recorded use of applied color. The furniture he used showed his interest in AG Fronzoni from Milan. The interior caused something of a sensation in the overheated climate of 1984. It appeared to have nothing in it. Not just no furniture or pictures, but no shelves, no books, no door handles, no washing machine, no sofa, and no bed—just nothing. He went on to design a commercial art gallery on Cork Street that demonstrated his

pursuit of the art of almost nothing and that looked to be entirely unpublishable: in all the photographs, you find yourself looking at the art, focusing on a prancing Flanagan hare rather than on the architecture.

I wrote about this gallery, using the word "Minimalism" much too casually to describe it. Pawson was as close to the art camp as any architect, but his work could not really be equated with the art movement of the same name. Pawson was certainly fascinated by Donald Judd. And to this day, his office has a Dan Flavin fluorescent on the wall, leaking red light wantonly across the white plaster. His architecture, however, has a different sensibility. In his buildings, technique matters a great deal; the sensual properties of materials and the calculations of proportion matter even more. It is, in some ways, a highly traditional view of architecture. In the twentieth century, architectural minimalism is an idea that can be seen to link Loos—certainly a minimalist, both in his writings and, equally, in his sensuous but restrained use of rich materials—with Ludwig Wittgenstein, whose house designed for his sister in Vienna certainly fully lived up to Judd's idea about "proportion being reason made visible."[2] Minimalism is a concept that can provide insights into the work of Mies van der Rohe, with his infinite spaces, and also that of Kahn, with his sense of monumental enclosure. Kuramata's delicacy and directness with materials and Luis Barragán's manipulation of

2 *Donald Judd: Complete Writings,
1959–1975* (Halifax: Nova Scotia College of
Art and Design Press; New York: New York
University Press, 1975).

Above: Ludwig Mies van der Rohe
Farnsworth House, Plano, Illinois, 1946–51

Facing page: John Pawson, Pawson House,
London, 1999

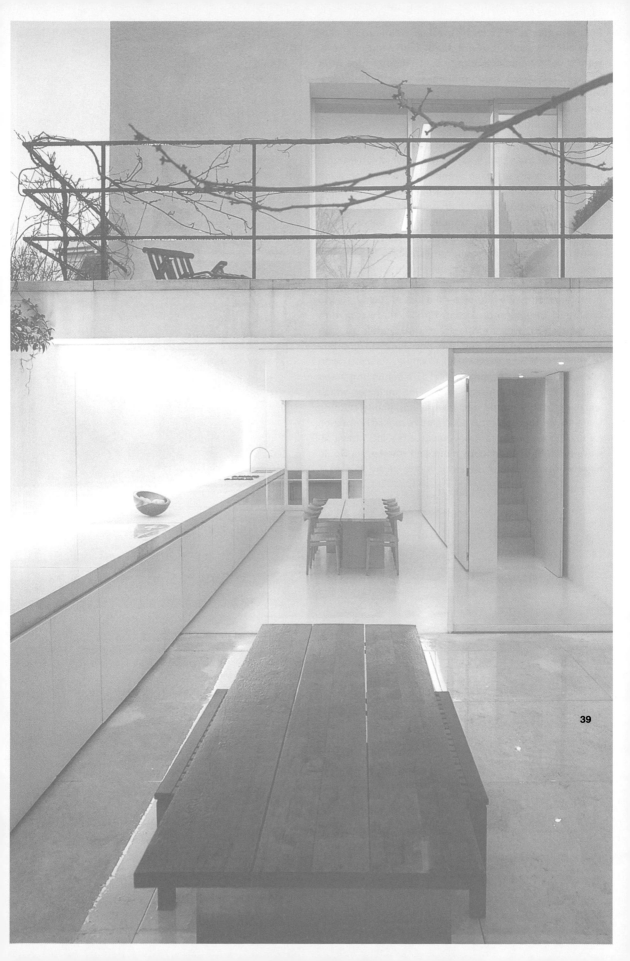

light and sky also reflect its values. Minimalism like-wise shapes some, but not all, of Tadao Ando's work, with its celebration of austerity. Taken together, the work of these architects, many of them self-taught and there-fore slightly out of the architectural mainstream, pro-vides an alternative view of a certain strand of what was once called Modern architecture.

What was perhaps newest about the minimal view of ar-chitecture of the 1980s was the way in which an interest in contemporary art gave architects like Pawson a jolt that served to remind them of what architecture might be. The connection between art and architecture is diffi-cult, contested territory, complicated by warring egos and awkwardness about the relative status of one a-gainst the other in the cultural hierarchy. But it is re-markable how often Judd's name comes up in architec-tural conversations today. There was something about his interest in place and site—like that of Richard Serra or Robert Smithson or James Turrell—that seemed to strike a chord with architects, who are, after all, inti-mately concerned with site, too. And Judd's own archi-tectural work was a powerful example. Pawson, who knew him personally, talks of him as a continuing inspi-ration. "Judd made changes to existing buildings which were incredibly subtle and he was constantly refining them. In photographs you don't always realize how much he had done, but in fact he usually did a lot. I have al-ways thought of Judd in my mind, and whether he would have wanted to show his work in one of my spaces."[3]

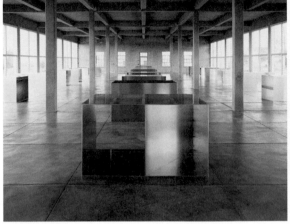

3 John Pawson, quoted in Deyan Sudjic, *John Pawson: Works* (London: Phaidon, 2000).

Above: Exterior view of artillery shed and shed interior (top) with permanent in-stallation of Donald Judd's 100 untitled works in mill aluminum, 1982–86. Collec-tion the Chinati Foundation, Marfa, Texas.

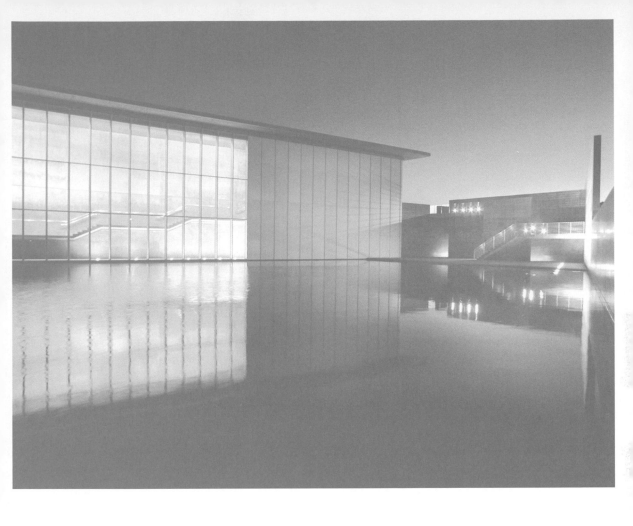

Above: Tadao Ando
Modern Art Museum of Fort Worth, Fort
Worth, Texas, January 1997–October 2002

Laconic Luxury:
Neo-Minimalism in the 1990s
Andrea Codrington

Architects and designers in the West have been experimenting with the reduction of form for roughly a century now, but never was Minimalism so powerful and ubiquitous a symbol than In the mid-to late-1990s, when it influenced everything from boutiques to B-2 bombers. While Minimalism might have been popular culture's shorthand for the good life—as expressed in the virtually overnight success of the lifestyle magazine *Wallpaper*—there was more to this trend in laconic luxury than might first meet the eye. The cultural drift toward formal simplicity occurred at the same time that traditional work roles and social interactions were being challenged and reshaped by innovations in personal computing, the Internet, and mobile technology. Minimalism's soothing forms and uncomplicated lines may have served to quell the inchoate sense that things were moving too rapidly, and, in some cases gave relief to a particular yearning for integrity or transcendence. The curvilinear mid-century modern furniture by such designers as Charles and Ray Eames and Arne Jacobsen found its way into all forms of media, lending a stylishly optimistic edge to films, music videos, TV commercials, and magazines.

Early proponents of Western minimalism often maintained a connection between material reduction and moral uplift—from the Shakers of the nineteenth century, who believed that objects should be perfectly built to last for eternity, to the fin-de-siècle Viennese architect and critic Adolf Loos, who insisted that "The evolution of culture marches with the elimination of ornament from useful objects."[1] Loos felt there was a connection between decoration and decadence and that a bracing dose of design without frills would greatly improve the Viennese moral condition. For Ludwig Mies van der Rohe, the father of International Style architecture, God was famously in the subtle details of buildings and objects.

Sacred Spaces

The twinning of minimalism and transcendence has been particularly emphasized in the design of commercial interiors, whether stores, restaurants, hotels, or spas. Architect Michael Gabellini—best known for his spare, powerful retail interiors for fashion designers like Giorgio Armani, Nicole Farhi, Ferragamo, and Jil Sander—aspires to create "aura spaces" that evoke a particular aesthetic and emotional resonance. Gabellini's 1993 design for Jil Sander's showroom on the Avenue Montaigne in Paris is a secular space that has all the hallmarks of the sacred—from its double-height vaulted ceilings and staircases that descend like Jacob's ladder to the interplay of floating horizontal and vertical planes and a lighting atmosphere that can best be described as ethereal. "Through the process of editing," says Gabellini, "you create the possibility of a potent concentration of experience. The everyday becomes elevated to a platform of awareness."[2] Of course the simplicity of the space is the result of an almost theatrical behind-the-scenes planning that considers every detail, from the way that a stair seam references the German designer's own precisionist tailoring to re-creating daylight in order to differentiate between subtle variations in the clothing's invariably black, blue, or gray palette. In Sander's Hamburg showroom—a historical villa on Lake Alster—Gabellini went to such lengths to establish an atmosphere of subtlety and light that he used more than fifteen different shades of white, putty, limestone, and gray in the interior.

Imbedded in Gabellini's retail spaces is the promise of transference—an implicit hope that the simplicity offered up by the space and clothing can be brought home to imbue life with similar clarity. The rituals of washing—a more direct, if external, route to purity—have also been examined through the lens of Minimalism, most strikingly in architect Peter Zumthor's thermal baths in Vals, Switzerland (1990–96). Unlike the Jil Sander stores, which are centrally located in large cities, Zumthor's baths are situated in a remote mountain town, making a trip to Vals tantamount to a pilgrimage. The massive quartzite and concrete structure sits on the side of a mountain, looking as much like something unearthed over centuries of winter storms as built by human hands. Emphatically rectilinear against a backdrop of rolling hills, Zumthor's design offers a series of stark cubic chambers filled to the walls with hot mineral water, icecold water, or steam. The striated quartzite and horizontal planes of the ceiling and water surface provide an almost subterranean effect that's emphasized by the fact

44

1 Adolf Loos, *Ornament and Crime: Selected Essays*, selected and with introduction by Adolf Opel, trans. Michael Mitchell (Riverside, Calif.: Ariadne Press), p. 167.

2 Michael Gabellini, in conversation with the author, February 2003.

3 John Pawson, in conversation with the author, January 1999.

that the building is entered through an underground tunnel. The movement from one space to the next—from heat to cold, from outside to inside and back again—form an overt physical manifestation of the mental and emotional transformation that can take place during the bathing ritual.

Minimalist design has also been effectively used in sites of transition, where a sense of temporal and physical dislocation can jangle nerves and weaken bodies. John Pawson, the British architect and designer best known for a monastic Minimalism that he has applied equally to Calvin Klein's Madison Avenue showroom, residences in the United States and Europe, and, appropriately

enough, a monastery complex in Bohemia, has had his greatest opportunity to spread his rigorous subtractionism in the 50,000-square-foot Cathay Pacific lounge he designed for Hong Kong's enormous Chek Lap Kok airport. Created as a decompression zone for first- and business-class passengers, Pawson's space is replete with minimalist alcoves filled with laptop-accommodating tables and armchairs, a library offering long plank tables and Phaidon art books, a 1,000-foot-long bar overlooking the mountains, and even a granite reflecting pool that runs the length of the entire space. Masking the fact that one is in an airport is difficult when announcements are made in several languages and planes are taking off overhead, but Pawson has managed to craft a peaceful retreat by subtly blocking views and focusing the eye instead on luxurious materials like black African granite, straight-grained Japanese walnut, and untanned oxhide. "It's not controlling what people do," says Pawson of his micromanaging of detail, "it's just controlling the environment in some sense so you can feel it."[3]

Mysterious Objects

Rampant consumerism—the overabundance of material objects designed for obsolescence—can be said to be partly responsible for contemporary society's material desensitization. By proposing fewer material possessions—and by carefully considering every detail—minimalist design can serve to imbue the everyday object

45

with power and even mystery. In 2002, Pawson came out with a small line of domestic objects for a Belgian company that features pared-down form and performative qualities that animate everyday activities in delightful ways. A black bowl rests mysteriously on its perfectly hemispherical bottom like an egg on end during the vernal equinox. Its smooth, curving proportions—reminiscent of the world's most elegant bowling ball cut exactly in half—conceal any indication as to how it can balance properly as it is tilted first one way, then another. "When an object is reduced to its essentials," says Pawson, "proportions come alive and simplicity takes on its own resonance and character."[4] The fact that the bowl maintains equilibrium due to its thick walls being weighted by sand doesn't take away from the initial impression that the object possesses some form of transcendent ability.

The element of surprise also plays a vital role in a line of clothing designed by Issey Miyake and his protégé Dai Fujiwara. Called A-Poc ("A Piece of Cloth"), the line features an almost alchemical transformation of raw material into finished product via a proprietarily programmed knitting machine. Simply explained, thread goes into the machine and a roll of cloth comes out bearing the shapes of sweaters, shirts, skirts—even hats and bags—that are released, cookie-cutter style, via a sharp pair of scissors. There is no sewing or tailoring necessary, so the hand of the designer is minimally felt, the Modernist ideal of a master artisan replaced by the digital intelligence of a zero- and one–crunching computer connected to a knitting machine. A-Poc shifts the final outcome of the line's aesthetic away from the designer and onto the end-user, who is able to modify each piece of clothing according to his or her preference. Variables like sleeve length, hemline and the like can be changed with a snip of the scissors without ruining the integrity of the basic form. "I think that the greatest achievement of the designer," says Miyake, "would be to disappear entirely into anonymity."[5] A-Poc's Minimalism transfers power from the designer to the wearer via the product.

Fashion's stock and trade is relaying the belief that donning a special garment can empower its wearer to do great things. Andy and Larry Wachowski, directors of the

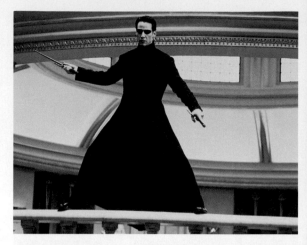

legendary *Matrix* trilogy, predicate their movies in part on this very idea and use minimalist black clothing as the vehicle of such power. "One of the costumes that was particularly important in the first film was the Neo coat,"[6] says costume designer Kym Barrett, referring to the tailored black tunic that makes the Keanu Reeves character look part Maoist cossack, part boutique-hotel doorman. Neo's transformation from ragamuffin machine-slave to matrixed-messiah takes place thanks to this sartorial switch. The reality he wakes up to after being summoned by Morpheus in the first film is a horrible one; he is dressed in sackcloth and rags and kept plugged into a machine that sucks his life energy. The minute he enters the computer Matrix to battle the virtual Agent Smith, however, he is transformed via a pair of ovoid sunglasses and a matte black coat which present a seamless front of invulnerability. He defies gravity, walks on walls, and is transformed from nebbish hacker to ninja warrior, all the while wearing the iconic coat-and-glasses ensemble that is emphasized in film trailers, publicity photos, and even six-inch action figures.

Minimalism isn't always life affirming, however. Sometimes its applications are dark and its magical feats troubling. Invisibility and stealthiness—the ability to virtually disappear from detection—has become a key strategy in products created for the United States Air Force. In the case of Northrop Grumman's B-2 "Spirit" stealth and

4 John Pawson, *Minimum* (London: Phaidon Press, 1998), p. 18.

5 Kazuko Sato, "Clothes Beyond the Reach of Time," *Issey Miyake: Making Things* (Paris: Fondation Cartier pour l'art contemporain, 1999), p. 81.

6 Kym Barrett, interviewed on the official *Matrix* Web site, http://whatisthematrix. warnerbros.com/rl_cmp/rl_interview_kym_barrett.html.

Above: Keanu Reeves in *The Matrix Reloaded* (Warner Brothers Pictures and Village Roadshow Pictures, 2003)

Facing page: John Pawson, *Bowl*, 2002 13 x 6 7/8 inches (35 x 17.5 cm), diameter 11 inches (28 cm)

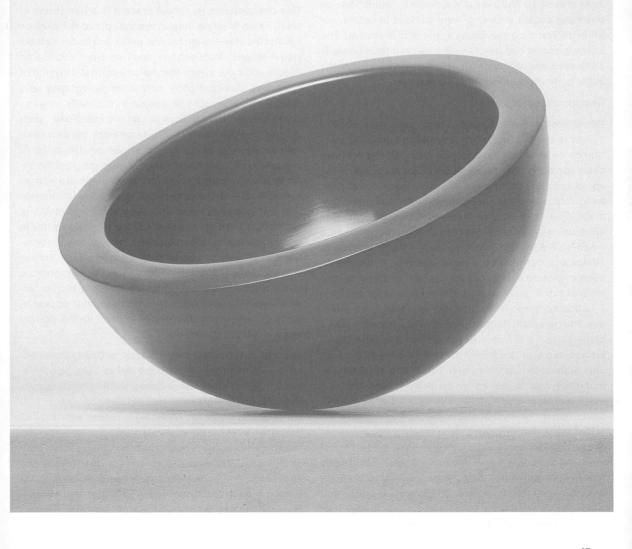

47

bomber—put into active service in 1997—the titanium carbon-fiber plastic minimalist shell serves to conceal roughly $2.1 billion worth of military industrial complexity. A simple flying wing with a continuously smooth and organic shape, the B-2's mandate of structural seamlessness manifests itself in a minimum of apertures in the body's surface, radar-foiling coatings, a zigzag form that scatters radar reflections, and a radiation proofing that protects it from the nuclear armaments it can carry in its own belly. The aircraft's nickname, "Spirit," has an unwitting double meaning—one patriotic in nature, the other referencing the plane's spectral presence. The sharp, stepped outline of the B-2 as seen from below is as totemic and terrifying an object as exists today—the angel of death in military-minimal uniform.

Dematerialized Design

Power may come wrapped in large packages when it comes to the B-2, but when it comes to consumer electronics it seems that the opposite is true. Designers have been speaking about dematerialization for a long time, about breaking computers and televisions out of their bulky boxes and imbedding them in our living environment. The flattening of three-dimensional consumer electronics into near-two-dimensional form has been a much-touted feature over the past five years, whether in computers, cell phones, or television sets. A new generation of plasma screen televisions have reduced the traditional box to such an extent that it now takes the form of a floating glass frame that sits on a wall like a painting. The perennial domestic cyesore of a television set's blank screen and space-hogging mass has been transformed into a simple geometric wall element. (If the benefits of dematerialization weren't clear enough in the object itself, one recent ad for the Sony Plasma WEGA™ Flat Panel Television features a photograph of a stripped-down, Japanese-style bedroom setting and tag lines like "All of these features combine to create a viewing experience that can only be described as transcendent"—associating Minimalism with spiritual enlightenment.) Sony is also soon to release the thinnest and lightest computer in the world, the Vaio Note 505 Extreme—a laptop that will measure approximately 9.7 mm thick and weigh less than two pounds. Hardcore proponents of cyber culture have often expressed disdain for the messiness and limitations of our own distinctly low-tech frames, so perhaps the ever-shrinking form of consumer electronics is as much an indication of a desire for bodily transcendence as it is a sign that small sells big.

Graphic design also underwent a period of intense reduction during the mid- to late-'90s, wherein aesthetic qualities normally associated with beauty and pleasure were eschewed for starkness and stripped-down utility. This phenomenon was most present in a new breed of small-batch lifestyle magazines that pitted themselves against the mainstream fashion press and its predictable visual tropes. Publications such as the Paris-based *Purple* spun out a Neo-Minimalist editorial design that employed blocky, tightly controlled typography and deadpan photography of people in distinctly unglamorous poses. Rather than mask imperfections, such graphic treatments tended to emphasize the awkwardness or ugliness of the subjects involved. The cover of one issue of *Purple* from 2000, for instance, has the upper third of the journal showing a photograph of a woman turned away from the camera facing a graffitoed concrete wall that is also covered with stray articles of clothing. The bottom third of the cover has the magazine's title in lower-case letters, a barcode that has become incorporated into the design rather than shunted off to a corner, and a great deal of empty white space. The juxtaposition of the magazine's name—one definition of which is "ornate"—and the emphatically reduced graphic approach lends an edgy irony that seems to send up the pretensions of glitzier treatments.

In a 1997 CD booklet called "Come to Daddy Remixed" for the drum-and-bass musician Aphex Twin (née Richard D. James), the London-based studio The Designers Republic created graphics that did away altogether with conventional album art, replacing it instead with text that describes what the photo would depict if there were one: "An image of children chasing after an ice-cream van from an Orange™ TV commercial advertising Text Messaging." The stark white Helvetica text against a field of orange is as ironically utilitarian as it gets; not surprisingly, the barcode is displayed as a design element on the CD's front. This Minimalist approach to music graphics is

48

7 Robert Venturi, *Complexity and Contradiction in Architecture*, with an introduction by Vincent Scully (New York: Museum of Modern Art, 1977), p. 17.

8 Donald Judd, *Donald Judd Furniture* (Rotterdam: Museum Boijmans Van Beuningen, 1993), p. 9.

An image of children chasing after an ice-cream van from an Orange™ TV commercial advertising Text Messaging.

taken to an extreme in British DJ/producer and designer Trevor Jackson's 12-inch single for the experimental quartet Fridge. Jackson has shifted the all-black cover's white type to run vertically up the left-hand side of the surface, anchored by the ubiquitous barcode. The band's name and the single's title, "Anglepoised," however, are cropped at the edge, and continued only inside the sleeve—a sly obscuring of information that is normally considered vital for record sales.

Responding to the ubiquity of reduced form in design in the early 1960s, eclecticist architect Robert Venturi wrote "Less is a bore,"[7] and it seems that for all its power and precedence in 1990s material culture, Minimalism's current popularity is fading as well. Ornamentation and craft have once again become dominant in furniture, fashion, and graphics, Minimalism's machine aesthetic replaced with the mark of the hand. Maybe the exigencies of reality in a post-9/11 age of economic downturn and ongoing war cannot countenance the rigors of Minimalism. Or maybe, as Donald Judd once said, "Old good ideas made new and shiny are now a dismaying precedent."[8]

Above: The Designers Republic compact disc cover, Aphex Twin, "Come To Daddy Remixed" (Warp Records, 1997)

Below: Fridge, *Anglepoised* (Output Recordings Limited, 1997), 12-inch single, design and art direction: Trevor Jackson

The Birth of a Notion:
Cinema and the Singular Form
Bruce Jenkins

51

A (very) brief history of film: a nineteenth-
century machine chemistry technology.
—Michael Snow

Cinema has proven to be a surprisingly fragile medium. The literature on film preservation is littered with case studies detailing the fiery ends and disintegrated remnants of movie masterpieces, with horror stories of nitrate explosions and the off-gassing debris of shrunken celluloid.[1] Nowhere is this impermanence more apparent, however, than in the history of experimental film practice, where the physical vulnerability of the medium is matched by the vagaries of critical memory, which has forgotten or misplaced whole chapters of the episodic chronicle of nonstandard filmmaking. Experimental cinema has operated almost exclusively on the margins of the medium, fueled by the obsessions of artists who have often found as little refuge in cultural institutions as in commercial ones. The vivid emblem of such a doubly marginalized mode can be discerned in the work of the pioneering underground filmmaker Jack Smith, who shot his masterpiece *Flaming Creatures* (1963) on outdated film stock, encountered resistance when the film was banned in New York State and was refused a screening of the work even at the preeminent international festival of avant-garde film in Belgium.[2]

Mistreatment of Smith notwithstanding, the 1960s marked a rare period of cultural aperture for experimental cinema, a time when there coalesced a critical mass of infrastructural supports for filmmakers working on the fringes of the medium: artist-run film distribution cooperatives; review space in arts weeklies and film journals; a loose network of exhibition venues; the first wave of funding from state arts councils and private foundations; and a brief embrace of individual artists by galleries and art centers. These supports in turn stimulated a welter of heterogeneous practices, ranging from the continued prominence of a diaristic "personal" cinema and mythopoeic works (like those of prodigious filmmaker Stan Brakhage) to cinematic forays by artists loosely associated with the Neo-Dadaist Fluxus movement and by experimental filmmakers responsive to the advanced practices that were transforming the other visual and performing arts of the era. When film critic P. Adams Sitney hailed the emergence of "a cinema of structure" in the late 1960s, he was reporting only on the most recent form

to have emerged from these synergistic encounters between film and the other arts.[3]

The predominant critical approach to interpreting the variety of experimental cinema that was emerging in the late 1960s and 1970s was a post-Greenbergian formalist reading, signaled by Annette Michelson when she first framed the new forms as "an investigation of the terms of cinematic illusionism."[4] While this characterization aptly captured a number of the essential features of these films—a focus on stasis and movement, flatness and depth, light and its absence—they could as readily have been interpreted in terms that were not so medium specific. That is to say, instead of invoking the material conditions of film these works were addressing, one might also have looked more broadly at the particular noncinematic artistic practices that often fueled individual interventions.

For example, when the mathematician-turned-composer Tony Conrad initiated his own filmmaking (having worked on the sound tracks for *Flaming Creatures* and Ron Rice's *Chumlum* [1964]), his innovative flicker films were directly inspired by his experience with the postserial-music collaborative Theater of Eternal Music. Similarly, when the dancer and choreographer Yvonne Rainer shifted from performance to filmmaking in the 1970s, she allowed independent cinema to partake of the lessons of the postmodern choreography that she had pioneered in the preceding decade. The painter-turned-filmmaker Paul Sharits, for his part, wedded his mastery of the visual elements of the medium—in films such as *Piece Mandala/End War* (1966) and *T,O,U,C,H,I,N,G* (1968)—with a Fluxus-like desire to remove the boundaries between art and life and to liberate the medium from the darkened halls of the theater. Photographer, theorist, and filmmaker Hollis Frampton likewise drew upon his knowledge of the history and methods of still photography to craft filmmaking that embraced a broader vision of the camera arts.

Looking back on the seminal era of the late 1960s and 1970s, we can chart the emergence and development of this "cinema of structure" in two periods: a renunciation

1 For the most recent and comprehensive assessment of the challenges facing film preservationists, see Roger Smither and Catherine A. Surowiec, eds., *This Film Is Dangerous: A Celebration of Nitrate Film* (Brussels: FIAF, 2002).

2 For a complete chronicle of the travails attendant to the production and reception

of this underground masterpiece, see J. Hoberman, *On Jack Smith's Flaming Creatures (and Other Secret Flix of the Cinemaroc)* (New York: Granary Books, 2001).

3 P. Adams Sitney, "Structural Film," *Film Culture*, no. 47 (summer 1969), pp. 1–10.

4 Annette Michelson, "Film and the Radical Aspiration: An Introduction," in Michelson, ed., *New Forms in Film*, exh. cat. (Montreux: Corbaz, 1974), p. 16.

Above: Paul Sharits
SYNCHRONOUSSOUND, 1974
Installation in the exhibition *Projected
Images*, Walker Art Center, Minneapolis,
September 21–November 3, 1974

followed by a regeneration. The former included works embracing a Zen-like emptying out of content, strategies emphasizing the rhythmic unfolding of light, approaches relying upon a sculptural handling of the physical material of the medium, and attempts to jettison all aspects of theatricality. The regeneration period coincided to a certain extent with the emergence of a second generation of so-called "Structural" filmmakers and their desire to integrate both personal and political content into an experimental practice. Much as the first generation was never in any functional sense a movement or school, the regenerative aspirations of the second remain at best provisional and partial. Yet together, these bodies of work laid the foundation for the extraordinary vitality with which the moving-image arts became inducted into the broader art world beginning in the 1990s, and for their now ubiquitous presence in arts festivals, biennials, commercial galleries, and museums. That this more contemporary work rests on the little-known efforts of these Structural filmmakers adds a genuine measure of timeliness to efforts at recovery and motivates an engagement in an avant-garde archeological excavation of the recent moving-image past.

The History of Film: "As It Should Have Been"

One of the more unlikely and yet productive sites to probe for the origins of a cinematic Minimalism might be that New York venue of excess known as the Factory. It was there, at a studio on East Forty-seventh Street, that over a course of two years in the mid-1960s Andy Warhol created a unique body of films that constitute not only a remarkable record of the personages who crossed the threshold of his studio-cum-salon but became part of the artist's systematic assault on the institution of the cinema. Warhol's nearly five hundred *Screen Tests* (1964–65) were the result of his tossing the pallette of expressive technique, along with conventional modes of cinematic production, out the Factory window and embarking (consciously or not) on an ambitious mission to remake the history of the medium by remaking some of its earliest works. Black-and-white, silent, static, unedited, confined to the cinematic duration of a single roll of film, and screened at the slower (flickering) speed of the silent era, these shorts radically reduced the medium to the formal elements available to the cinema's first generation of practitioners such as Thomas Edison and the Lumière Brothers. Moreover, Warhol's occasional directions to his screen-test subjects (not to move, not even to blink) further rewound the history of the medium back to the precinematic era of the still photograph and the magic-lantern slide. The artist achieved a purity of form closely mimicking the originating visual appeal of the medium, as well as being not entirely unrelated to the means by which he was paring down the images in his silk-screen paintings to their iconic substrata—appropriating news photos, publicity stills, and consumer items and distilling them to their flattest, most elemental visual representation.

At a less tony location on Canal Street in Lower Manhattan, in a modest venue named Fluxhall, a six-week series of Flux Concerts was presented in the spring of 1964. On an evening in early May, the performance program included the first screening of an experimental film by the artist Nam June Paik entitled *Zen for Film* (1962–64).[5] Designed to accommodate a live interactive performance, Paik's film filled a portion of the screen at the rear of the stage area with a bright empty frame of white light, a function of its appropriated origins as 16-mm clear leader. Paik had created a model Fluxfilm by circumventing the standard protocols of both production (camera, lights, decor) and postproduction (editing, sound mixing, printing), and in the process created an imageless work that foregrounds the materiality of the medium by presenting on-screen the unseen physical support of cinema—the blank celluloid. Like a Heissenbergian allegory, *Zen for Film* directly portrays the hidden journey that every film makes through the transport mechanism of the projector, a passage visibly changed by each viewing and recorded on its celluloid surface in the form of accumulated scratches, dust, dirt, and tears. To Paik—a post-Cagean composer—this enterprise was not unprecedented. Later in the decade, spectators would encounter similar investigations of light in the works of artists Robert Irwin and James Turrell, among others.

54

5 For two useful descriptions of this seminal work, see John Hanhardt, "Picturing Movement, Past and Present," in *Moving Pictures: Contemporary Photography and Video from the Guggenheim Museum Collections*, exh. cat. (New York: Guggenheim Museum, 2003), pp. 25–26; and Bruce Jenkins, "Fluxfilms in Three False Starts," in *In the Spirit of Fluxus*, exh. cat. (Minneapolis: Walker Art Center, 1993), pp. 136–37.

LIBRARY & MUSEUM OF THE PERFORMING ARTS

55

Above: Tony Conrad and Beverly Grant
arriving September 16, 1966, at the New
York Film Festival's exhibition space in
Lincoln Center to show *The Flicker* (1965),
which Conrad is carrying in a brown
paper bag.

The rehearsal studio and performance space at the Judson Dance Theater in New York was another unlikely arena for the emergence of a new film form. Since, as Rainer, a Judson founder, acknowledged, dance had always been "the most isolated and inbred of the arts," it was all the more remarkable to find in the mid-1960s "a close correspondence between concurrent developments in dance and the plastic arts."[6] Rainer carefully charted the parallels between the elements of then-current Minimalist art (factory fabrication, unitary forms, uninterrupted surface) and the corresponding strategies of the postmodern dance ("found" movement, equality of parts, repetition). This became the basis of her singular intervention within dance and the grounds for her gradual embrace of experimental filmmaking. For Rainer, her early short films like *Volleyball* (1967) and *Line* (1969) were "an extension of my concern with the body and the body in motion."[7] They were meant to be viewed en passant and served as elements of the Minimalist decor in sections of her pieces that also included live performance. These modest shorts with their nonnaturalistic scenery and tableau-vivant staging, prefigured Rainer's later shift into a quasi-narrative mode and her radical remaking of the genre of melodrama.[8]

Eye (S)training Films

The works that would emerge as canonical within the nascent Minimalist cinematic form often took aspects of the physical material of the medium and the attendant modes of seeing to extreme ends. Conrad, for example, pursued the imageless approach of Paik and made one of the first stroboscopic films, *The Flicker* (1965), using alternating patterns of black and clear frames. In the 1970s, Conrad explored "alternative mechanisms," as he termed them, "to working with the material other than using the camera."[9] The methods that emerged conjoined his long-standing antiauthoritarian rejection of convention; resistance to the industrial (in this case, "Kodak") norms of the machine era; and commitment "to express some sentiment about the material and the way I felt a-bout it." For *4X Attack* (1973), Conrad explained how he "took the film in the darkroom and indulged myself in a very expressionist impulse with a hammer."

The roll of high-speed, black-and-white film stock "splintered apart into many many many small pieces," which Conrad carefully reassembled to complete the production. His films of that time involved a series of such actions visited upon the filmstrip, including *Bolled Shadow* and *Pickled 3M 150 10544-31* (both 1974).

Among the most radically reductive of the Minimalist cinema of this period were the films of Ernie Gehr, who initiated a series of resolutely challenging works that became defining texts in an exploration of the constitutive aspects of light, image, and movement. His *Morning* and *Wait* (both 1968) are short silent works in which the filmmaker initiated his exploration of "the essential contradictions of still and shot by enormously emphasizing the still-frame."[10] With its image emptied of all extraneous content, Gehr's work vigorously appeals to an apperceptive mode of film viewing, one that entails a singular attunement to the conditions of visibility and subtle shifts in depth and motion. His masterpiece in this regard is the aptly titled *History* (1970), a work that for Gehr captured the medium "in its primordial state," and which the artist and filmmaker Michael Snow—author of an ur-text of Minimalist cinema, *Wavelength* (1966–67)—humorously (but accurately) hailed as "at last, the first film!" *History* consists exclusively of swirling photographic grain as a defocused camera navigates shallow spaces and inchoate patches of light and darkness.

Such filmmakers' narrowed, reflexive gaze upon the medium itself privileged not only the physical materiality of the filmstrip (sprocket holes, grain, dust, processing errors) but also the various stages of the production process. George Landow's *Film in Which There Appear Sprocket Holes, Edge Lettering, Dirt Particles, etc.* (1965–66) is a Minimalist masterpiece in which he reprinted a portion of the color test-strip footage of a "Kodak girl" along with the adjacent sprocket holes and other usually unseen parts of the filmstrip. A narrative film created solely from still images of the pages of its script, Frampton's *Poetic Justice* (1972) foregrounds the equally unseen arena of preproduction. In similar fashion, Morgan Fisher focused on a polar endpoint of the process by transforming the normally unacknowledged act of film

6 Yvonne Rainer, "A Quasi Survey of Some 'Minimalist' Tendencies in the Quantitatively Minimal Dance Activity Midst the Plethora, or an Analysis of *Trio A*," in Rainer, *Work 1961–73* (Halifax: Press of the Nova Scotia College of Art and Design, 1974), p. 64.

7 Rainer, "Films," in ibid., p. 209.

8 For one of the earliest and most perceptive readings of this process, see B. Ruby Rich, *Yvonne Rainer* (Minneapolis: Walker Art Center, 1981).

9 All quotations in this paragraph are from Tony Conrad, untitled remarks, June 15, 1974, *Millennium Film Journal*, nos. 16–18 (fall/winter 1986–87), p. 257.

10 Ernie Gehr, "Program Notes by Ernie Gehr for a Film Screening at the Museum of Modern Art, New York City," in Michelson, *New Forms in Film*, p. 67.

Above: Hollis Frampton
Still from *Poetic Justice*, 1972

projection into a performance piece. His *Projection Instructions* (1976) is addressed to that "passive mechanic" hidden behind the projection port in the back wall of the theater, and the resulting film is an interactive work in which the "score is visible, but the performer is not."[11] This film thus consists of instructions to the projectionist to adjust the focus, change the frameline, and perform other technical acts normally considered extraneous but here brought to the fore.

The End of Film

Less than a decade after the emergence of a rigorously Minimalist mode of experimental filmmaking, signposts marking its end appeared in the form of a pair of comic critiques by experimental filmmakers fully conversant with the "Structural" mode. The first of these is Landow's *Wide Angle Saxon* (1975), an experimental fiction about a man who experiences a religious conversion while watching a "long and boring" Structural film made by "someone named Al Rutcurts." The film-within-the-film condenses Landow's own *Remedial Reading Comprehension* (1970) with Frampton's *Nostalgia* (1971) and consists of shots of red paint being poured over a wide variety of objects, including a hot plate—the item that had served as the centerpiece in Frampton's film. In James Benning's feature-length *Grand Opera* (1978), the filmmaker created a personal and artistic autobiography that ranges not only over his life and travels but equally across the evolution of the Structural film, which is rendered in amusing homages to the work of Snow, Frampton, Landow, and Rainer.

Meanwhile, serious debates ensued amid a bevy of proclamations about the "end of the avant-garde" and the "death of cinema."[12] Nevertheless, the mid-to-late 1970s was a remarkable period for experimental filmmaking, both among the originating group of artists and their aesthetic progeny. The latter group, a sort of second generation of Structural filmmakers, emerged during a period of enormous change within the arts and the world at large that effectively altered the relationships between an avant-garde film practice and other advanced artistic forms. For filmmakers like Benning, Bill Brand, Abigail Child, Su Friedrich, Leslie Thornton, and many others, this meant creating work that registered the formal innovations of the recent past while reasserting the position of the personal and expressive, the social and political, and even aspects of narrativity and reportage. The cinemas of Frampton and Snow, Sharits and Conrad, Rainer and Gehr had initiated a set of aesthetic and cultural connections that brought the cinema out of its insular black box; these artists effectively opened up and reinvigorated a uniquely cinematic space for formal experimentation, personal exploration, and social engagement. Although Minimalism as a catalytic force and an end in itself came to bear for only a brief time on a body of moving-image creation, the singular embrace this Minimalist cinema offered to the materials of the medium and to the general artistic zeitgeist forever realigned filmic practice and allowed it, eventually, to enter the realm of art.

11 Morgan Fisher, "Projection Instructions," in *Ten Years of Living Cinema* (New York: Collective for Living Cinema, 1982), p. 9.

12 Among the most despairing proclamations are Fred Camper, "The End of Avant-Garde Film," in *Millennium Film Journal*, nos. 16–18 (fall/winter 1986–87), pp. 99–124; and the more abbreviated précis for Camper's panel "Cinema's Phoenix: Deaths and Resurrections of the Avant-Garde" in *International Experimental Film Congress* (Toronto: Art Gallery of Ontario, 1989), pp. 32–33. For a more measured analysis, see Paul Arthur, "The Last of the Last Machine? Avant-Garde Film Since 1966," *Millennium Film Journal*, nos. 16–18 (fall/winter 1986–87), pp. 69–93.

Judson Dance Theater and
the Brave New World of Dance

Gia Kourlas

In the early 1960s, the Judson Dance Theater invigorated the field of dance by rejecting the past. Judson member Yvonne Rainer, a choreographer and filmmaker, stated the group's intention in a 1965 manifesto: "No to spectacle no to virtuosity no to transformations and magic and make-believe no to the glamour and transcendency of the star image no to the heroic no to the anti-heroic no to trash imagery no to involvement of performer or spectator no to style no to cap no to seduction of spectator by the wiles of the performer no to eccentricity no to moving or being moved."[1]

Rainer and her fellow Judsonites were reacting against more than commercial dance. Threatening the prospect of experimentation was ballet, with its overriding image of grace, elegance, and technical virtuosity, and modern dance, traditionally expressive and earnest (and overrun with social themes or mythological storytelling). Avant-garde choreographer Merce Cunningham was the Judson group's touchstone. While his movement was highly technical and closer in its virtuosity to ballet than to traditional modern dance (as it still is), his practice of working with visual artists and creating choreography using chance procedures was an inspiration. Suddenly, a dance could be about movement; it didn't have to tell a story, yet, like contemporary art, it could be full of the same nuance and power. Rainer's four-and-a-half minute *Trio A* (1966), for example, consisted of a series of constant changes in motion performed as a single phrase.

Oddly enough, Mikhail Baryshnikov, a ballet star, recently paid homage to several of Judson's Minimalist masterpieces. His PASTForward tour, which traveled across the United States and Europe in 2001, featured works by Trisha Brown, Lucinda Childs, Simone Forti, David Gordon, Steve Paxton, and Rainer, performed by Baryshnikov's White Oak Dance Project and directed by Gordon. The program was a cohesive success, both for its smooth direction—it wasn't the real Judson, and Gordon knew it—as well as for the way in which it transformed into flesh and blood dances that many in the audience had only read about in books by Sally Banes, who has chronicled the dance of the period.

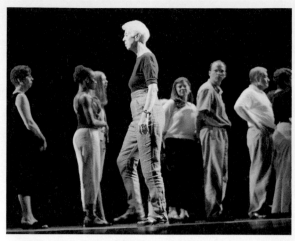

Still, it was not possible for the dances to look the same as they had when first performed—and not only because the grandeur of the Brooklyn Academy of Music's opera house, where the program was performed in New York, was so far removed from the austere gymnasium of the Judson Memorial Church in Greenwich Village, the original venue for many of Judson's performances. The White Oak dancers, especially Baryshnikov, could not hope to mirror the sensibility of the Judson performers, many of whom were coveted for their unpolished ways. (Formal training as a dancer was considered entirely unnecessary by the Judson group.) Yet even though the dances undoubtedly lost some of their spontaneous and subversive flavor, the program nevertheless added up to something more inspiring than a history lesson by bringing the dances to life. Childs's *Carnation* (1964), an odd portrait focusing on a housewife gradually succumbing to insanity, saw dancer Emily Coates matter-of-factly stuffing her mouth full of kitchen sponges. In Gordon's ironic yet poignant *Overture to "The Matter"* (1979), a stream of ordinary people crossed the stage to Léon Minkus's music from the seminal "Kingdom of the Shades" scene from Marius Petipa's nineteenth-century ballet *La Bayadère*. The ballet features a full corps de ballet descending onto the stage from a ramp in the back, deliberately and delicately weaving their way to the front in a simple arabesque-tendu phase; Gordon replaced

1 Quoted in Sally Banes, "Yvonne Rainer: The Aesthetics of Denial," in *Terpsichore in Sneakers: Post-Modern Dance* (Boston: Houghton Mifflin, 1980), p. 43.

Above: Valda Setterfield (in foreground) and members of the local community perform in David Gordon's *Overture to "The Matter,"* 1979, White Oak Dance Company performance at McCarter Theater, Princeton, New Jersey, August 2, 2000

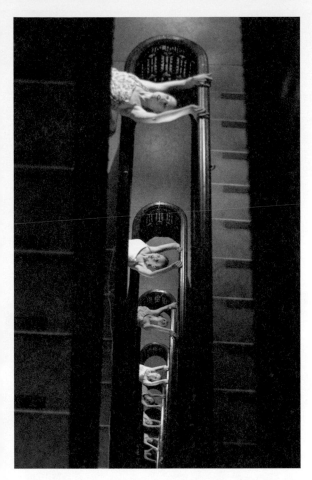

In the late 1970s and 1980s, unconventional choreographers turned to the proscenium, including the witty experimenter and former Judson member Trisha Brown. *Glacial Decoy* (1979) featured projected photographs by Robert Rauschenberg and five dancers wearing diaphanous white dresses. The dancers slipped on and off the stage, giving the illusion that there were many more. By figuring out how to make contemporary ideas about choreography work on the traditional proscenium stage, Brown made touring—the only way to sustain a company—finally feasible. Other choreographers followed suit by creating dances suitable for touring, but the dance boom was over, and in the 1990s choreography became tainted by a deadly sameness. The work of experimental downtown choreographers during this time was defined more by process than by theatrical innovation; often what appeared onstage wasn't a fully formed work but a perfectly respectable idea spread painfully thin. Around the time of Baryshnikov's PASTForward tour, however, the staid state of dance began to change, and several of the choreographers who had seemed crippled by the past now became artists.

While there are many choreographers who use the term "contemporary" when what they are doing is more in line with traditional dance, hip-hop, or jazz than with experimentation, there are others who have taken in the influences of the past to create their own future. Rather than using elements of design or costume as decor, tacking them on at the end of the creative process as they were in the time of Balanchine or Martha Graham, these artists integrate them from the beginning; they are as important as the choreography, and that changes everything. The dance becomes more than a dance; it becomes a piece of conceptual art, sharing more in common with installation art than with typical concert dance. Rather than collaborating with visual artists, these choreographers are more often influenced by them (Matthew Barney, Damien Hirst), as well as by experimental theatrical troupes such as the Wooster Group.

these ghostly white figures with pedestrians crossing the stage while their faces were projected onto a screen at the rear. This revelatory piece—both simple and complex—summed up the concept of Judson succinctly and with more grace, strangely, than the piece that ended the program: Childs's *Concerto* (1993), a pure movement piece that could only be performed by experienced dancers.

Just as the ballet world remains stifled by the timeless memory of George Balanchine, contemporary dance has suffered much from the breakthrough ideas of Judson: What is there left to rebel against?

To a certain extent—at least when it comes to the work of these experimental choreographers—the days of the tidy

Above: Noémie Lafrance
Descent, 2001
Performed at The Clocktower,
New York, 2002

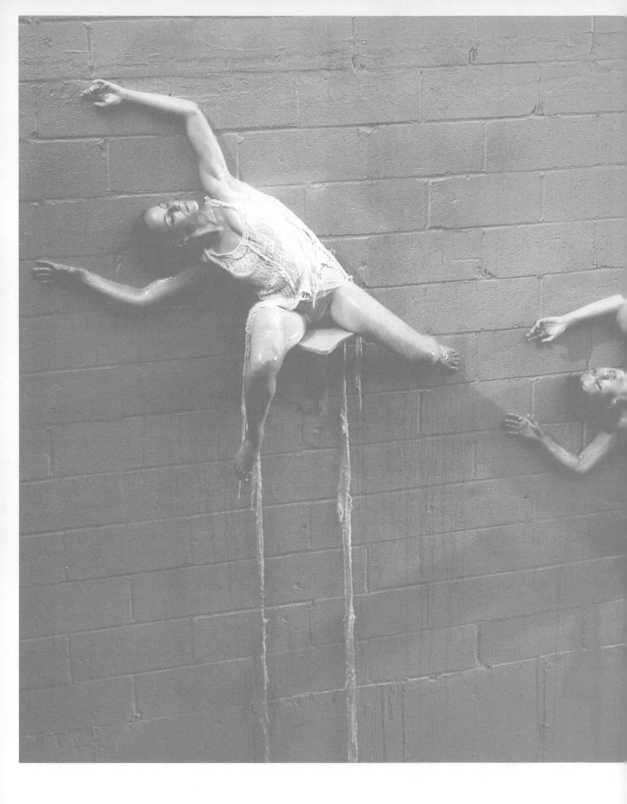

Noémie Lafrance
Melt, 2003
Performed at the Black and White Gallery,
Brooklyn, New York, June 2003

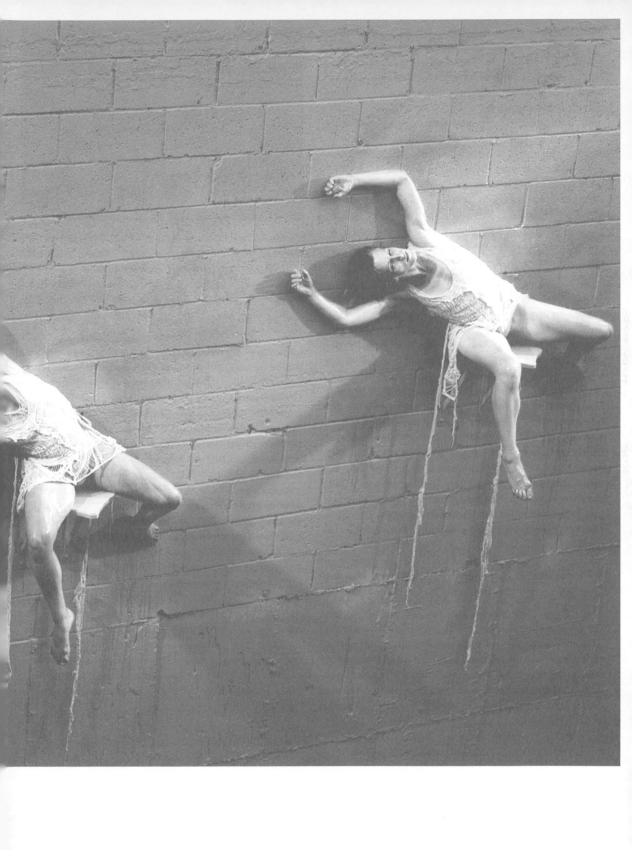

twenty-minute piece are over. The current tendency among contemporary choreographers is to present a single full-length work, and that vision is important to note: Artists are more interested in capturing a specific world than in creating a work that can play on the tour circuit. (Producers, fearful of not selling out a performance, avoid booking choreographers who shun the status quo, which is why it's difficult for the rest of the United States to compete with New York; how, for instance, can a Midwestern choreographer live up to his or her potential if he is only served a steady diet of Alvin Ailey?) In certain cases, the world created by a choreographer is unveiled in an unconventional setting; in others, the stage is a theater overhauled for the occasion of the dance. This is territory that was conquered by Judson, but it is fresh when the right choreographer is involved; above all, what is required is imagination.

French-Canadian choreographer Noémie Lafrance possesses an abundance of this elusive ingredient and has managed to create a bold theatrical world on both a small and a large scale. Her recent site-specific works *Descent* (2001) and *Melt* (2003) were performed in a twelve-story stairwell and a Williamsburg, Brooklyn art gallery, respectively. In *Descent*, Lafrance, who trained extensively at the school of the Martha Graham Center of Contemporary Dance, planted her audience at the top of a stairway in a city court building in downtown Manhattan. She then transformed the grimy stairwell into a place of eerie beauty. As the audience stared down onto the lower depths of the swirling banister, twelve female dancers leaned over its edge from the top to the ground floor, appearing less like performers than like phantoms. The magisterial vantage point and skewed perspective created an image of infinity, and the ethereal effect was akin to watching a painting get up and dance. As the audience descended the stairs, the experience was less dreamlike and more like entering another world; you were part of it.

For *Melt*, a fifteen-minute-long work, Lafrance created costumes from a mixture of beeswax and lanolin. Three dancers, again all women, balanced atop seats bolted onto an exposed-brick wall; their "chairs" were camouflaged by their stiff dresses and their movement was

minimal. Their task was simple: to melt. Lafrance's translation of this potentially hackneyed image into a poetic and visceral work of art was breathtaking. Using costume, lighting, and movement, she avoided heavy-handedness, knowing just how far to push the obvious, then pulling back just in time for the audience's imagination to take over.

Lafrance's command in creating avant-garde movement-theater is curious, given her fairly conventional training. She is the only choreographer to have emerged from the Graham milieu with a particular vision that neither draws from her mentor's groundbreaking movement vocabulary nor is derivative of it. The classic Graham contraction—in which the stomach muscles contract, propelling the torso into a sensuous curve—may be part of Lafrance's picture, but there is nothing particularly reminiscent about it. Her next piece, *Noir*, explores the world of film noir and is to be performed in a parking garage in New York in May 2004. While her earlier works have been influenced by the cinema, it is her main influence in this piece: She wants the dance to be every bit as frightening and surreal as a black-and-white film of the 1940s. Audience members will watch the dance from automobiles while the score is played over the cars' radios. While Lafrance's conceptual work possesses a gloss removed from the dances of the 1960s, it accomplishes something that many Judson choreographers also hoped to achieve: the breakdown of the invisible curtain between audience member and performer. She writes of *Noir*: "The juxtaposition of the real space and the stylized

2 See http://www.sensproduction.org/noir.
htm (January 13, 2004).

Above: Sarah Michelson
Shadowmann, Part 1, 2003
Performed at The Kitchen, New York,
April 2003

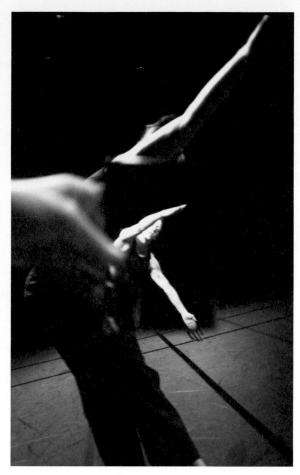

action creates the illusion of an event that appears to take place both in reality and in fiction."[2] The audience is at once part of the dance and voyeur.

New York–based, Manchester-born choreographer Sarah Michelson also stages her dances in unconventional settings; the difference, however, is that she reconfigures traditional spaces to suit her needs. More than any other choreographer working today, she is a conceptual artist who possesses an easy affinity for movement invention. Unlike the many choreographers who show promise at first but soon sputter, churning out the same basic idea with dreary repetition, Michelson is a treasured anomaly whose works have expanded the notion of dance-theater.

While Michelson considers herself to be a choreographer first and foremost, her creative breadth encompasses more; no element of a work, whether costumes, lighting, music, or movement, is less important than the other—or that's the way it seems. Even more exacting than Lafrance, she creates startling new worlds, from the bubble-wrap floor and the race car driving across a horizontal screen suspended above the dancers in *The Experts* (2002), for White Oak Dance Project, to the transformation of a tiny theater into a white chimera with the help of wall-to-wall carpet in *Group Experience* (2001). In *Shadowmann, Parts 1 and 2* (2003), she transformed the work's two venues—the Kitchen and P.S. 122 in New York—from places of drab familiarity into mystical dwellings—as long as the dancers remained onstage, at least. In *Part 1*, she flipped the seating arrangement so that the audience faced not a blackened back wall, but doors that opened to the street. When the show was over, five of the performers (teenagers dressed in Dolce & Gabbana) were whisked away in a white limousine. In *Part 2*, the performers escaped from a side door in a veritable flash, visible through a window as they walked along the sidewalk in single file. It was odd and slightly deflating to be left staring at an empty stage, but the sensations both dances created through environment and physicality remained in the air—a prickle of memory like the residual effect of a lightning bolt.

Michelson is inspired both by the theaters she works in and by the eclectic group of people she works with, from Mike Iveson, a gifted dancer with no formal training who also creates the scores for her works, to Parker Lutz and Greg Zuccolo. Performance quality is just as important to her as the transformation of space. While her works are decidedly eccentric and glamorous, she adheres to Rainer's "no to involvement of performer" and "no to seduction of spectator by the wiles of the performer." Her dancers' specific movements, from their fierce relevés and exhausting runs to their impassive facial expressions, are directed with the same specificity an artist uses to stroke a canvas with the most delicate of paintbrushes. And because all the elements—from the music to the choreography to the set—are so perfectly constructed, the viewer cannot help but be moved. Watching

Michelson's work is like sunning oneself in imagination so rich that choosing where to look—often there are several things going on at once—becomes a dire predicament.

Contemporary choreographers, like their Judson counterparts, avoid stories; Michelson's dances, for example, though they hint at cynicism, exhilaration, and finding beauty in the most odd and familiar places, aren't really about anything. In *just two dancers* (2003), New York–based choreographer John Jasperse played with the notion of space, transforming the Dance Theater Workshop in New York from its standard proscenium setup into a wholly new environment by building platforms over the seats and supplying the audience members with mirrors, which they could use to watch those parts of the performance taking place on the mini wooden stages behind them. It was, in many ways, like a Happening—that form of performance art that coincided, and overlapped, with Judson's innovations—but there was nothing spontaneous about it; rather, this piece of dance-theater was carefully planned and meticulously devised from beginning to end. Though Jasperse often incorporates tasks into his choreography, as did the members of Judson, the difference is in the way these activities are carried out: the task is not a means to an end—or a way of proving that anything is dance—but a deliberate part of the theatrical landscape; it is the scenery.

The experiments of Judson continue to have enormous influence on today's choreographers. Their history is a burden to some, but not to all. For every misguided imitation of the 1960s, there is an artist like Michelson who is not content to rest on her laurels, but strives to push the boundaries of the form. A true daughter of Judson, she has absorbed the daring and fearlessness of that era, but updated it to embrace a more contemporary theatrical vision. Her dances are about nothing in particular; they do, however, epitomize the sensibility of what the world is like in the very instant they are performed.

New York is once again in a cycle of producing the most distinctive and enthralling contemporary dance in the world. Making a dance a conceptual event that in no way resembles the staid style of European dance-theater is the point. It's either a bizarre or an unfortunate coincidence that such resurgence is happening in such a depressed economy, when funding for new choreography—embarrassingly scarce in this country at the best of times—is harder to obtain than ever. But the concerns of money—or the lack of it—has not restrained contemporary dance; rather, the work has regained a polish and ingenuity that was, for years, lacking. Choreographers today aren't only challenging convention; they are challenging their own imaginations. The goal isn't making a work suitable for far-reaching tours, but one that is luminous and exists in the present. And the result is full-bodied euphoria, not just for the performer, but for those of us, slack-jawed and tingling, fortunate to be sitting in the audience.

Next to Nothing
Drew Daniel

The official story is that white canvas triggered silent music. Transposing the invisible into the inaudible, in 1952 John Cage wrote *4'33"* in response to Robert Rauschenberg's *White Paintings* of the previous year. Nine years later, in an essay on his friend, Cage explicitly bound their work together in an intimate sequence:

To Whom It May Concern: The white paintings came first; my silent piece came later.—J.C.[1]

Consolidating a canon by announcing a debt, Cage here presented his work as somehow both interchangeable with and a belated response to Rauschenberg's visual precedent. Describing the impact of Rauschenberg's paintings in a conversation on the genesis of the silent piece, Cage confessed to a kind of competitive mandate delivered by "the *example* of Robert Rauschenberg. His white paintings. . . . When I saw those, I said, 'Oh yes, I must' otherwise I'm lagging, otherwise music's lagging.'"[2] While this gasp of personal ambition confirms his humanity, Cage's sense that music might be lagging behind painting is curious, given that in 1948 he had already proposed that a silent composition of three to four minutes in length, entitled *Silent Prayer*, be broadcast on the radio.[3] Chronological quibbles aside, one can see and hear why Cage felt the two pieces belonged together, and why the performed experience of *4'33"* specifically constituted a valid response to the *White Paintings* while the propositional character of *Silent Prayer* did not: both Rauschenberg's *White Paintings* and Cage's *4'33"* hinge upon a trust in the capacity of the given environment not only to compensate for, but to surpass, the expected aesthetic payoffs. Wiping the slate clean of both figurative content and Abstract Expressionism's gestural trace, the *White Paintings* embody a confidence in the material plenitude of seeing as an activity. In a structural analogue, Cagean silence, while empty of musical expression, is scandalously found to be always already filled with sound. In both works, the space for personal expression becomes a vessel into which the audience and the world outside the art object are invited to abide.

If the *White Paintings* are, as Cage described them, "airports for shadows,"[4] then *4'33"* is flypaper for coughs, a fine net catching chair squeaks and traffic hum. Silence isn't, in fact, silent at all, but is teeming with what Douglas Kahn has termed "the always sound."[5] In almost a miraculous reversal of the Fall, we find ourselves, after our encounter with *4'33"*, to be already living in a paradise of ontic particularity, one in which, according to Cage's Zen-via-Los Angeles formulation, "Every day is a beautiful day."[6]

Cage's sunny platitude conceals a razor-sharp threat, however, for if every day is beautiful, then no day is especially beautiful. Indeed, Cage's absolute freefall challenges aesthetics at their core, leaving standards of value judgment or critical appraisal set aside, if not anarchically leveled. Despite Cage's private worry that music not lag behind, Cagean mindfulness halts the impulse to correct or improve the given, sapping momentum from the careerist impulse to "make it new" and Whiggish historical narratives of progress and improvement. While Cage may be said to have, in Heideggerean terms, "named it into existence," the very plenitude and persistence of this "always sound," once heard and grasped as a continuum, works to undo the historical chain of progress upon which avant-gardes and art movements tend to stake their legitimacy. Now dissolves into *always*, and *always* into *now*.

The very thoroughness of Cage's reduction makes essays of this kind perilous. Without history, "ideas," intention, content, expression, meaning, or judgment, how to proceed? What followed in the wake of Cagean silence was a proliferation of compositional strategies, musical practices, soundings, and habits of receptivity whose scope necessarily and generously exceeds all possible mastery and taming, whether in the space provided here, or in any other. Neatly creasing the twentieth century in half, Cagean silence shattered outward into an aporetic babel of plural camps and registers that differ wildly in their local articulation but that all draw energy from the founding aesthetics of reduction. What binds them is a shared starting point within the busy silence of the "always sound," and working methodologies that move outward from that silence by reduction, erasure, negation, or conceptual practices of restriction to a minimum of sonic material.

1 John Cage, "On Robert Rauschenberg, Artist, and His Work," *Metro* (Milan), May 1961; reprinted in Cage, *Silence: Lectures and Writings* (London: Marion Boyars, 1968), p. 98.

2 John Cage with Roger Shattuck and Alan Gilmore, "Erik Satie: A Conversation," *Contact* 25 (autumn 1982), p. 22 [italics added by the author].

3 Douglas Kahn, *Noise Water Meat: History of Sound in the Arts* (Cambridge: MIT Press, 1999), p. 159.

4 Cage, *Silence*, p. 102.

5 Kahn, *Noise Water Meat*, p. 159.

6 Cage used this phrase often, as in an interview in the documentary film *John Cage: I Have Nothing to Say and I Am Saying It*, directed by Alan Miller (The Music Project for Television/PBS American Masters series, 1990).

I

TACET

II

TACET

III

TACET

NOTE: The title of this work is the total length in minutes and
seconds of its performance. At Woodstock, N.Y., August 29, 1952,
the title was 4' 33" and the three parts were 33", 2' 40", and 1'
20". It was performed by David Tudor, pianist, who indicated the
beginnings of parts by closing, the endings by opening, the key-
board lid. However, the work may be performed by any instrument-
alist or combination of instrumentalists and last any length of
time.

FOR IRWIN KREMEN JOHN CAGE

John Cage, score for *4'33"*, 1952

If the attentive silence demanded by *4'33"* relies upon the institutional context or discursive frame of musical performance (seated performer, instrument, quiet audience, the formality of a concert hall), its humor, friction, and danger lie in the critical pressure it places upon that context. Yet the piece has an insidious capacity to circulate outside that context, to take place wherever and whenever one chooses to be silent and attentive. It also has a jokelike communicability as a concept, and this has given it a cultural longevity and purchase far in excess of the small number of individuals who have seen it performed. In this sense, *4'33"* prepared the way for a flood of instructions for performed actions that hover along the fluid boundary between musical composition and Conceptual art, from George Brecht's *Drip Music* (1959, "A source of dripping water and an empty vessel are arranged so that the water falls into the vessel"), to La Monte Young's X to *Henry Flynt* (1960, the bare instruction to play any sound "x" number of times), to Yoko Ono's *Wall Piece for Orchestra* (1962, "Hit a wall with your head"), to the Fluxus work of Takehisa Kosugi, Nam June Paik, and Ben Vautier.[7] Abiding in a textual interzone between poem and recipe, these conceptual proposals, circulated independently of their realization in performance (which in some cases was strictly impossible anyway), both draw upon and parody the normative illocutionary force of standard sheet music. But if Conceptual art drew its strategic mobility from the example of the musical score, it was the uniquely transmissible nature of *4'33"* that first signaled the openness of both the musical composition and the context of musical performance to critical intervention and play.

Musique Concrète and the Everyday as Raw Material: Luc Ferrari and Toshiya Tsunoda

A materialist extension of the listening habits commenced in *4'33"*, Luc Ferrari's *Presque Rien n. 1, le lever du jour au bord de la mer* (1970) commits the Cagean "always sound" to tape, transposing it from a real-time encounter with the listener's contingent surroundings to a gentle immersion in the prerecorded sounds of a particular location. In this case, the "almost nothing" (presque rien) Ferrari invokes in the work's title is an entire teeming world of everyday sound compiled from field recordings made in a fishing village on an island in the Dalmatian archipelago. With a meditative calm alien to most musique concrète, Ferrari's work invites its audience to quietly listen to the sounds of the world on their own terms, and the result is a portable experience of a specific time and place. What could have been an ambient blur is actually a crisp inventory of quotidian phenomena: insects tick, a motorboat putts off, a donkey snorts, people talk, trucks pull up, a woman sings to herself. Ferrari's microphone placement (on a windowsill) puts a gently domestic, humanist frame around these sounds and takes them as they come. Behind the scenes, however, an entire day has been telescoped into twenty minutes, collapsing twenty-four hours into a compressed narrative structure—but unlike the athletic displays of tape-manipulation prowess favored by other practitioners of musique concrète, Ferrari concealed any overt transformation. All is calm, and the results are a breathtakingly direct expression of faith in the musicality of everyday sound. Ferrari's title humbly positions his work as an asymptotic divergence from absolute silence, but the movement from nothing to these quiet sounds encompasses the entire world of human action in a sonic ontology of great scope and tenderness.

Almost thirty years on, Toshiya Tsunoda's work likewise embodies a principle of trust in the spatial richness and presence of a "framed" but otherwise untampered with field recording. Tsunoda curates and presents what he calls "extractions": recordings of acoustic circumstances as they pass. In examining the "vibration phenomena peculiar to specific spaces," his work flickers between a preservative impulse to document how a site becomes a "place" and a self-conscious foregrounding of the editorial decisions implicit in his own selection and placement of microphones.[8] If Ferrari is ultimately interested in humanity and the acoustic modeling of an experience for an implied listener, Tsunoda directs his microphones elsewhere, pursuing not sounds as they might show up for someone, but vibration as a trace of physical material itself. In his explanation of *A sign-board, windblown* (1997), Tsunoda provides a miniature narrative of the

74

7 Edward Strickland, *Minimalism: Origins* (Bloomington: Indiana University Press, 1993), p. 142.

8 Toshiya Tsunada, "About Two Works," in Brandon La Belle and Steve Roden, eds., *Site of Sound: Of Architecture and the Ear* (Los Angeles: Errant Bodies Press, 1999), p. 146.

recording as a volatile interface between intermittent phenomena and technology: "A contact microphone was set in the gap between wooden frame and iron sheet. Whenever the sign waved in the wind, it touched the contact microphone, transmitting, for a moment, the vibration traveling through the iron sheet."[9] Shot through with a weirdly animist pathos that defies the work's materialist rationale, Tsunoda's extraction offers us the promise of access to a drama of fleeting, microscopic contact between objects, the fantasy that we could overhear the mutterings of the thing-in-itself, even as it clearly signals the prosthetic dimension of its enabling apparatus. Capturing intensely quiet and barely present phenomena and amplifying them into the range of our hearing, Tsunoda's work further extends Cage's project by drawing our attention to the boundaries of hearing as a material encounter.

With a Minimum of Means: Charlemagne Palestine's *Strumming Music* (1975)

What is a composer to do after *4'33"*? While Fluxus artists composed actions and concepts and proponents of musique concrète curated experiences of access and recordings of everyday sound, others fashioned a music from a bare minimum of musical materials, a music whose surface lack of compositional gesture allows us to hear it as sound first—not a music of sound, but music as sound. The New York School of composers—including Earle Brown, Morton Feldman, and Christian Wolff—drew inspiration not only from Cage's reductive aesthetics, but also in opposition to dogmatic European serialism, fashioning in response (particularly in the case of Feldman) a music whose stark isolation of individual notes in vast pools of expectant silence cancel normal thematic development in favor of an immersion in each individual moment on its own terms. If, over the past thirty years, the musical terrain bounded by the phrase "Minimalist composition" has been increasingly stretched and distorted—and, in the process, many of its most visible practitioners, including Feldman and Philip Glass, have disowned the phrase—there is nonetheless a coherent principle at work, a kind of musical transcription of Buckminster Fuller's Dymaxion principle (maximum functional impact from a minimal outlay of material). But what does that sound like?

To take an example from Minimalism's "middle kingdom," Charlemagne Palestine's *Strumming Music* (1975) rubs two notes together and starts a fire in the mind. With the sustain pedal of the piano constantly depressed, two keys are insistently played against each other (one, two, one, two . . .), allowing subtle variations in timbre and volume to manifest themselves, gradually and inevitably. By the fifth minute, overtones emerge from the minute differences in phrasing and intensity as the two tones beat against each other, limning the middle distance with a metallic horizon line. Gradually, the listener begins to hallucinate ghostly flutes and buzzings and electronic tones as the overtones grow increasingly complex and harder to square with what we recognize as the sounds of a piano. After twenty minutes, patterns seem to zigzag and switchback across one another, vertiginously climbing and spilling out into crop-duster loops. By the fortieth minute, what began as the merest tapping on two keys achieves an oceanic cumulative power.

Strumming Music bears the marks of "Minimalism" as that generic tag has come to selectively characterize a by-now-familiar group of academic American composers (Young, Terry Riley, Steve Reich, Glass, and John Adams): there is a steady, continuous rhythmic pulse, the work is diatonically tonal, it is recognizably, and "pleasantly," harmonious, and it develops through a formally basic process of addition (first two notes, then another, then another, then another). As with most so-called schools, however, the internal coherence of this group tends to evaporate upon closer examination, for none of these defining features is consistently present in all of their work, and most of these features are absent from the work of Minimalism's arguable founder, Young. Indeed, the most austere expressions of this tendency, such as Young's *The Four Dreams of China* (1972), eschew rhythmic pulse in favor of disorientingly static streams of rigorously structured and utterly spartan pitches. In the drone plateaus of Young and Tony Conrad (a cofounder of the Theatre of Eternal Music, along with Young, John Cale, Angus MacLise, and Marian Zazeela),

9 Toshiya Tsunada, liner notes to
O Respirar da Paisagem (SIRR, 2003).

as well as in the more recent drone works of Phill Niblock, pitches are held for such extensive durations that the ear becomes retrained to perceive extremely subtle differentiations in tone, color, and intensity, with the microrhythms of individual frequencies gradually manifesting themselves after prolonged listening and the staggered entrance of new notes registering as powerfully transformative interventions. The effect is a stasis-within-sound that cancels temporality, and it is miles away from the highly rhythmic, clearly marked temporal grids and motorik momentum of Palestine, Reich, and Riley.

If the lush colors of canonical Minimalism's most populist moments—such as Riley's In C (1964) or Reich's Music for 18 Musicians (1976)—are difficult to square on theoretical grounds with the radical erasure of Cage, it is nonetheless arguable that these new organisms could only have thrived in the clearing opened for them by 4'33", prefigured as they were by early compositions such as Young's Trio for Strings (1958), in which extended silent rests constitute a large part of the formal syntax through which Minimalism first defined itself.[10]

Screen Memories: Bernhard Günter's Un Peu de neige salie (1993)

Changes in technology have made it possible to repeat and elaborate the "same" reductive compositional gesture across media platforms, in the process uncovering and amplifying features specific to each idiom. With the shift from analog to digital recording technology, the possibility of an absolute silence, which Cage had famously foreclosed with his assertion that sound persists even in the utterly silent laboratory conditions of anechoic chambers, finally became a compositional option. Its most radical advocate is German sound artist Bernhard Günter. Speaking in a deliberately flat and offhand manner about his composition Untitled II/92 (1992), Günter describes his work as "computer sequenced using digitally edited samples in a kind of 'what-you-hear-is-what-you-get' compositional approach that uses flex-ible strategies rather than a preconceived system."[11] The dominant impression is of a capricious and evasive sprinkling of ashy, very occasional rustling noises punctuated by stark spaces of absolute silence extending from three to forty-five seconds over the course of thirteen minutes.

While this internal separation of nearly indistinguishable sections itself replays the internal structuring of Cage's 4'33" (which is divided into three subsections of varying length), the on-screen environment in which Günter's work is constructed allows for an absolute silence whose valence is, in principle, quite distinct from the receptivity and plenitude of the Cagean "always sound." Taken on its own terms as sound, it may represent the ne plus ultra of a specifically digital art practice, in which perfect silence is, at least within the composition, storage, and playback medium, finally possible. Vinyl, blessed and cursed by its more immediate and tactile surface vulnerabilities and friction-based mechanism, could never provide true silence, as any owner of a dog-eared LP copy of Feldman's Rothko Chapel (1972) can readily attest. Bracketing the airless perfection of utter silence, Günter's recording, in the real world of home-stereo playback, induces a kind of phenomenological encounter with one's personal threshold of audibility, triggering frequent exploratory trips back to the volume knob for its would-be listener. There are, of course, many precedents for recordings created specifically for low-volume playback, two notable examples being Robert Ashley's Automatic Writing (1979) and Nurse With Wound's A Missing Sense (1986, a tribute to Ashley), but Günter's work remains pioneering in the thoroughness of its exploration of the new capacities for quiet afforded by software environments and compact discs.

That said, over the past decade an increasingly large community of like-minded experimental musicians, some using electronics and some sourcing their work from concrete sounds, has sprung up, giving rise to a minigenre of intensely quiet and stark music dubbed "microsound" or "lowercase." The organic end of the spectrum, which tends to focus on bristling field recordings and a concern with spatial dynamics, includes the work of Loren Chasse, Brandon LaBelle, Francisco López, Steve Roden, and Giancarlo Toniutti. Taking inspiration from the "sonic ecology" movement of archivist/composers such as Annea Lockwood and Hildegard Westerkamp,

10 Strickland, Minimalism, p. 119.

11 Bernhard Günter, liner notes to Un Peu de neige salie (Table of Elements, 1996)

these sound artists capture grainy snapshots of fleeting natural phenomena (wind in trees, an insect chorus in a rainforest, water on stone, the scraping of dried branches), in which human interference seems entirely absent, providing a tenuous audio link to a vanishing world of the uncivilized "real." Replacing a natural sublime with a technological one, the electronic end of the lowercase or microsound movement, as exemplified by the work of Richard Chartier, Taylor Deupree, Ryoji Ikeda, Carsten Nicolai, Nosei Sakata, and Miki Yui, focuses upon computer-generated tones at the extremes of the audio spectrum, punctuated by stark blocks of total silence. Evoking not the forest but the everyday technological landscape of grounding electrical hum and high-speed modem dial-up screams, their work spans a rainbow of pulses from gently evanescent mists of barely audible bass drones all the way up to painfully bright, laser-precise high-frequency zaps, whose piercing insistence creates an experience for the listener that is as much medical as it is musical. For all the studied trappings of psychoacoustic research, microsound composers actually pursue very basic questions about perception: How quiet can a sound be before it disappears? How low can a sound be before we stop noticing it? How high can a tone get and still register?

Working in close proximity to this group and overlapping with some of its key players (Ikeda, Nicolai) is a school of electronic Minimalists who deploy a similar vocabulary but plug it back into the rhythmic sequences of dance music. Frank Bretschneider, Byetone, Coh, Komet, Panasonic, and SND all straddle the divide between a techno-inspired programming practice and an attention to rigorously restricted sound design, parsing the same extreme highs and lows into a more clipped syntax of microedited beats fashioned out of crisp digital sparks and percussive clicks. Though it is underacknowledged academically, there is a widespread dissemination of Minimalist aesthetics, both visual and auditory, within the electronic underground. From the crisply repetitive formalism of the classic Detroit techno of Robert Hood, Jeff Mills, and Underground Resistance, to the transparent graphic-design sensibility of label Raster-Noton's *20' to*

Top: La Monte Young, The Tortoise, His Dreams and Journeys, "7", 1964–present. Concert at The Four Heavens (Larry Poons's studio), New York City, February 6, 1966, performed by The Theatre of Eternal Music (from left to right): La Monte Young, Marian Zazeela, Terry Riley, voices; Tony Conrad, violin. Light projection design: Marian Zazeela.

Bottom: *20' to 2000*, conceived by Carsten Nicolai (Raster-Noton, 1999). Twelve issues of 20-minute compact discs with magnetic link system.

2000 series, to the overt homage to Anish Kapoor in the cover art for Richie Hawtin's *Consumed* (1998), to the names of labels Basic Channel, Line, M-nus, and Vertical Form, Minimalism continues to serve as inspiration, example, and signifier.

Empty Samplers and Feedback Loops

In a gesture of willfully perverse refusal analogous to Cage's present but unplayed piano, Toshimaru Nakamura's work for "no input mixing board" and Sachiko M's work for "empty sampler" are two recent examples of a performance practice that deliberately denies these standard models of consumer electronics their intended content and function, enforcing a kind of ad hoc poverty of utterance onto the performer. Nakamura generates a surprisingly varied vocabulary out of the internal routing paths of his starved mixing board, coaxing the ghostly imprint of hum and bleed from layer upon layer of re-applied equalization, coiling channels back into themselves until the gain structure of output going back into input and coming out output and going back into input again knots and winds itself into gusts and snarls of mercurial machine noise. This use of a recombinant feedback loop as a source of aleatory transformation can be traced back to one of the first "process" compositions, Reich's *Pendulum Music* (1968), in which microphones are allowed to swing back and forth above corresponding speakers, building an increasingly dense chorus of feedback until they all finally come to a resting position.[12] Bypassing such allegories of entropy in favor of a gloriously overdriven vicious circle, Lou Reed's infamous double LP *Metal Machine Music* (1975) transposes the same technique to linked chains of amplifiers, inscribing its formal principle of looped recursion into the locked groove that extends the end(?) of side four indefinitely. David Lee Myers's work for customized electronic feedback generators (under the name Arcane Device), as in his LP *Engines of Myth* (1988), retraces the same figure eight.

These figures of recursion and repetition mark a fitting analogy for the avant-garde legacy of *4'33"*, for the continually transformative return to the "same" gesture describes the impact of Cage's seminal work upon subsequent musical practice. It is an endlessly fertile negation that seems to trigger new translations, and new silences, in each following generation. *4'33"* shows the horizon line between sound and music to be both porous and permanent, endlessly fragile and inexorably present. Yet in a sense, the very gesture that commences a tradition is also its high-water mark. Musical practice after *4'33"*, though it has harnessed the energy of noise and absorbed the lessons of silence, still remains, stubbornly, "music." People began to compose differently after Cage, but they didn't stop composing or calling what they compose "music." While Cage may have hoped that we would hear sound on its own terms as sound and surrender our expectations of intentionality and form, the practical impact of his revolutionary gesture has been, in fact, an expansion of the parameters of what can be experienced as music, rather than a replacement of music by something else. The longed-for subordination of music to sound as such has only been partially achieved, and, if anything, the encounter has worked the other way: any sound, or noise, or found terrain of silence can now be colonized for the sake of enriching and expanding the kingdom of music.

12 Michael Nyman, *Experimental Music: Cage and Beyond* (New York: Schirmer Books, 1974), p. 12.

PENDULUM MUSIC

FOR MICROPHONES, AMPLIFIERS, SPEAKERS AND PERFORMERS

2, 3, 4 or more microphones are suspended from the ceiling by their cables so that they all hang the same distance from the floor and are all free to swing with a pendular motion. Each microphone's cable is plugged into an amplifier which is connected to a speaker. Each microphone hangs a few inches directly above or next to it's speaker.

The performance begins with performers taking each mike, pulling it back like a swing, and then in unison releasing all of them together. Performers then carefully turn up each amplifier just to the point where feedback occurs when a mike swings directly over or next to it's speaker. Thus, a series of feedback pulses are heard which will either be all in unison or not depending on the gradually changing phase relations of the different mike pendulums.

Performers then sit down to watch and listen to the process along with the audience.

The piece is ended sometime after all mikes have come to rest and are feeding back a continuous tone by performers pulling out the power cords of the amplifiers.

II

B

Steve Reich 8/68

Plates

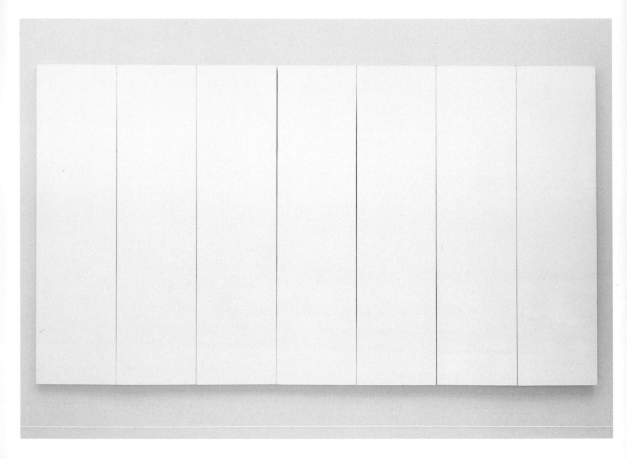

82

Robert Rauschenberg
White Painting [seven panel], 1951

Oil on canvas
72 x 125 x 1 1/2 inches
(182.9 x 317.5 x 3.81 cm)

Collection of the artist

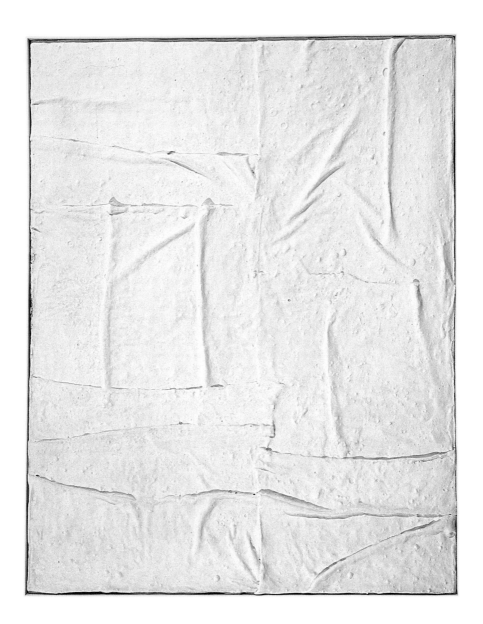

Piero Manzoni
Achrome, 1958

Kaolin on creased canvas
25 1/2 x 19 3/4 inches (65 x 50 cm)

Courtesy Michael Werner Gallery,
New York and Cologne

84

Ad Reinhardt
Abstract Painting, 1960–66

Oil on canvas
60 x 60 inches (152.4 x 152.4 cm)

Solomon R. Guggenheim Museum,
New York. By exchange
93.4239

85

Frank Stella
Die Fahne Hoch!, 1959

Enamel on canvas
121 1/2 x 73 inches (308.6 x 185.4 cm)

Whitney Museum of American Art, New York; Gift of Mr. and Mrs. Eugene M. Schwartz and purchase, with funds from the John I. H. Baur Purchase Fund; the Charles and Anita Blatt Fund; Peter M. Brant; B. H. Friedman; the Gilman Foundation, Inc.; Susan Morse Hilles; The Lauder Foundation; Frances and Sydney Lewis; the Albert A. List Fund; Philip Morris Incorporated; Sandra Payson; Mr. and Mrs. Albrecht Saalfield; Mrs. Percy Uris; Warner Communications Inc. and the National Endowment for the Arts
75.22

Ellsworth Kelly
Orange/Red Relief, 1959

Oil on canvas, two panels
Overall: 60 x 60 inches
(152.4 x 152.4 cm)

Solomon R. Guggenheim Museum,
New York. Gift of the artist
96.4511

Ellsworth Kelly
Blue, Green, Yellow, Orange,
Red, 1966

Oil on canvas, five panels
Overall: 60 x 240 inches
(152.4 x 609.6 cm)

Solomon R. Guggenheim Museum,
New York
67.1833

Agnes Martin
White Flower, 1960

Oil on canvas
71 7/8 x 72 inches (182.6 x 182.9 cm)

Solomon R. Guggenheim Museum,
New York. Anonymous gift
63.1653

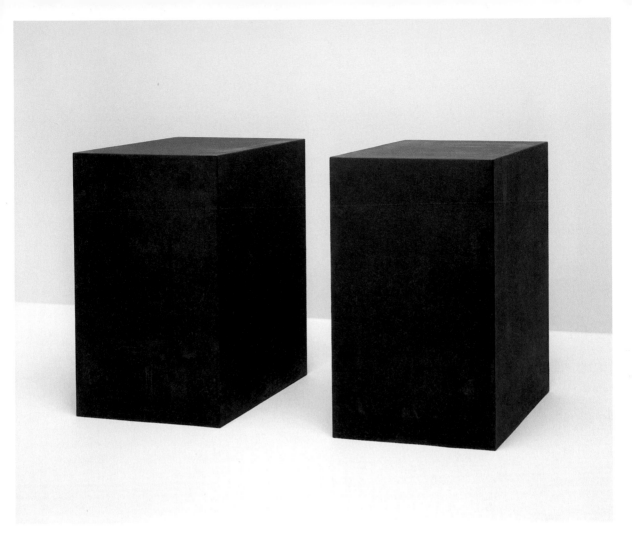

89

Tony Smith
For W.A., 1969

Welded bronze with black patina
Edition 1/6
Each unit: 60 x 33 x 33 inches
(152 x 83.3 x 83.3 cm)

Solomon R. Guggenheim Museum,
New York. Purchased with the aid of funds
from the National Endowment for the Arts
in Washington, D.C., a Federal Agency;

matching funds contributed by the Junior
Associates Committee
80.2753

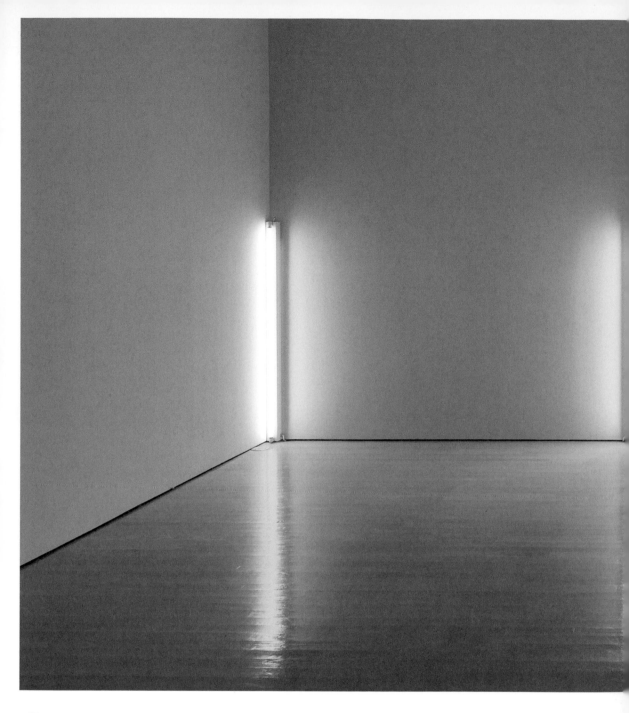

Dan Flavin
the nominal three (to William of Ockham),
1963

Fluorescent light fixtures with
daylight lamps
Edition 2/3
Height: 72 inches (183 cm); overall
dimensions variable

Solomon R. Guggenheim Museum,
New York. Panza Collection
91.3698

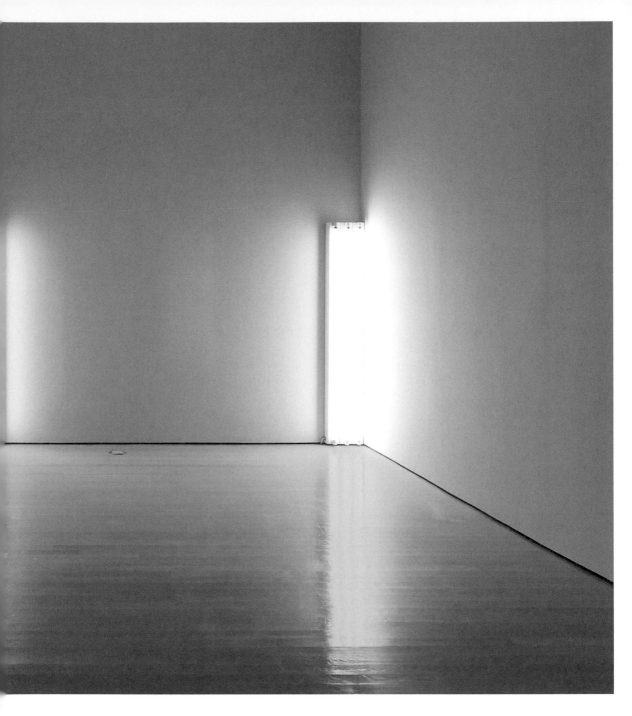

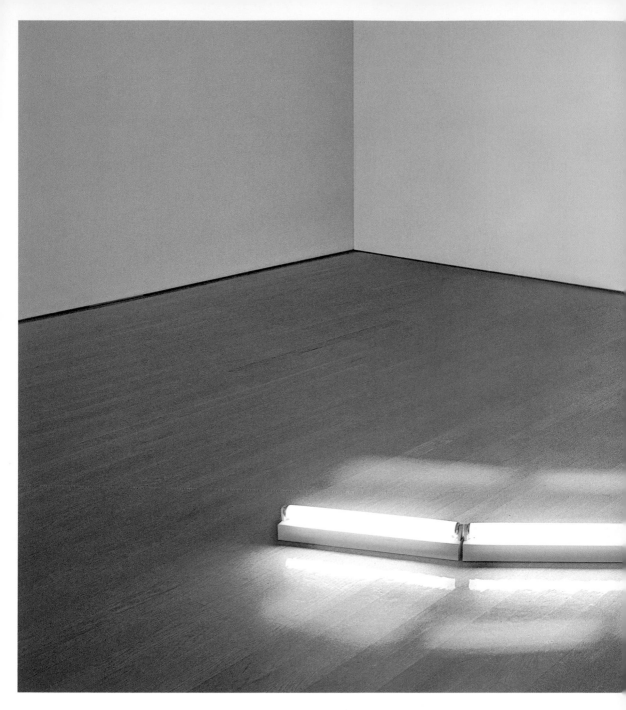

92

Dan Flavin
untitled, 1964

Fluorescent light fixtures with cool
white deluxe lamps
Edition 1/3
Overall: 4 x 133 1/2 x 84 inches
(10.2 x 339.1 x 215.3 cm)

Solomon R. Guggenheim Museum,
New York. Panza Collection
91.3700

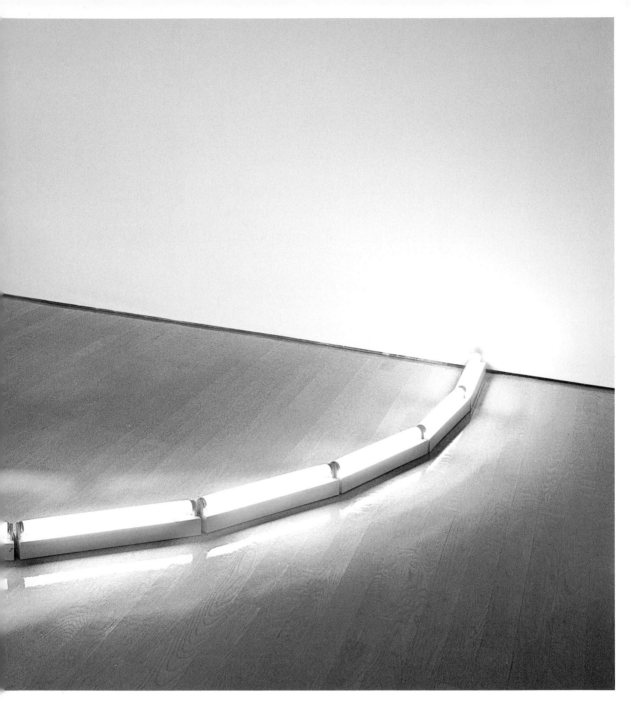

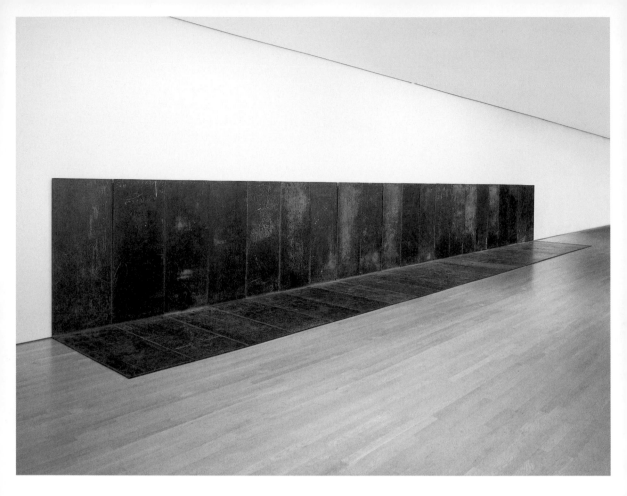

94

Carl Andre
Fall, New York, 1968

Hot-rolled steel, twenty-one L-shaped units
Overall: 72 x 588 x 72 inches
(182.9 x 1493.5 x 182.9 cm)

Solomon R. Guggenheim Museum,
New York. Panza Collection
91.3670

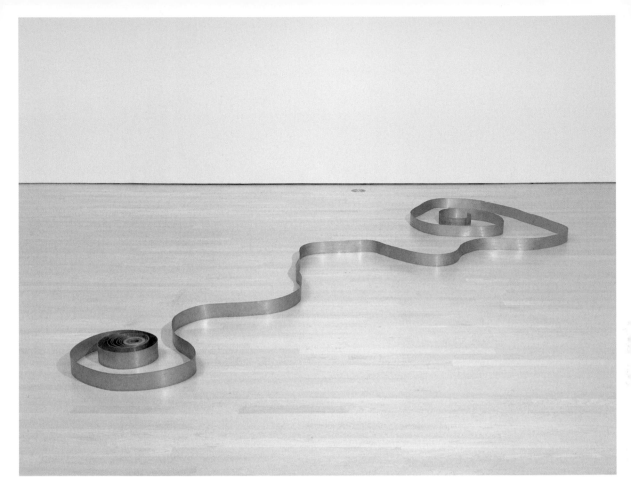

Carl Andre
Zinc Ribbon, Antwerp, 1969

Zinc, one continuous strip
1/16 x 3 9/16 x 826 3/4 inches
(0.1 x 9 x 2,100 cm)

Solomon R. Guggenheim Museum,
New York. Panza Collection
91.3672

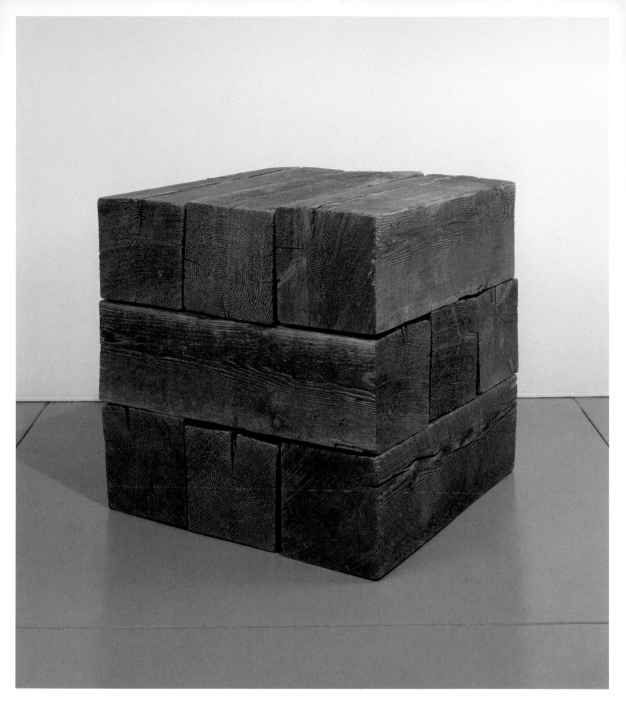

96

Carl Andre
Trabum, 1977

Douglas fir, nine units
Overall: 36 x 36 x 36 inches
(91.4 x 91.4 x 91.4 cm)

Solomon R. Guggenheim Museum,
New York. Purchased with funds
contributed by the National Endowment for
the Arts in Washington, D.C.,
a Federal Agency; matching funds

donated by Mr. and Mrs. Donald Jonas
78.2519

98

Brice Marden
Private Title, 1966

Oil and wax on canvas
47 3/4 x 95 3/4 inches
(121.3 x 243.2 cm)

Solomon R. Guggenheim Museum,
New York. Panza Collection
91.3782

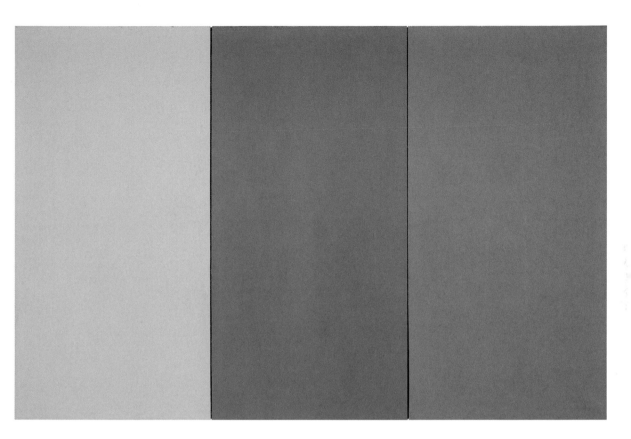

Brice Marden
D'après la Marquise de la Solana, 1969

Oil and wax on canvas, three panels
Overall: 77 5/8 x 117 3/8 inches
(197.2 x 298.2 cm)

Solomon R. Guggenheim Museum,
New York. Panza Collection
91.3784

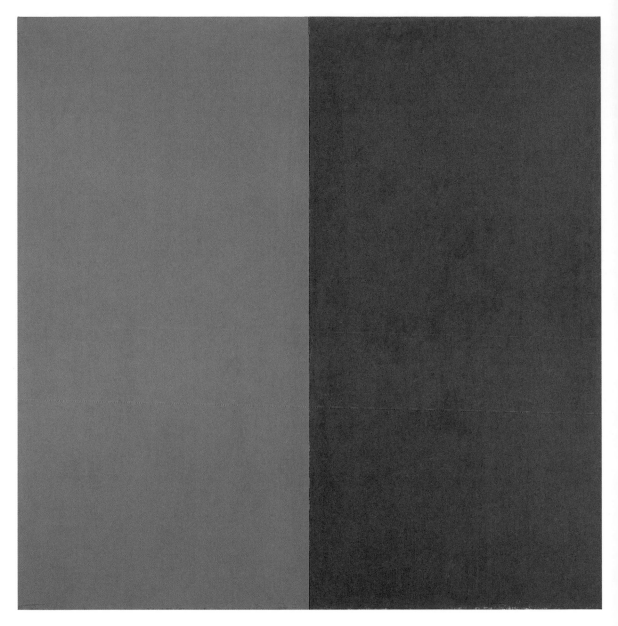

100

Brice Marden
Untitled, 1973

Oil and wax on canvas, two panels
Overall: 72 x 72 1/8 inches
(182.9 x 183.2 cm)

Solomon R. Guggenheim Museum,
New York. Panza Collection
91.3789

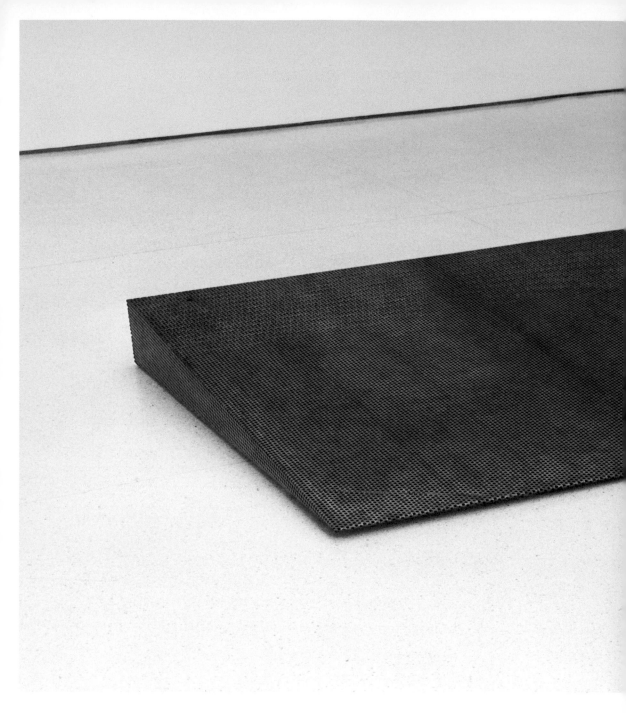

102

Donald Judd
Untitled, 1968

Perforated 12-gauge cold-rolled steel
8 x 120 x 66 inches
(20.3 x 304.8 x 167.6 cm)

Solomon R. Guggenheim Museum,
New York. Panza Collection
91.3712

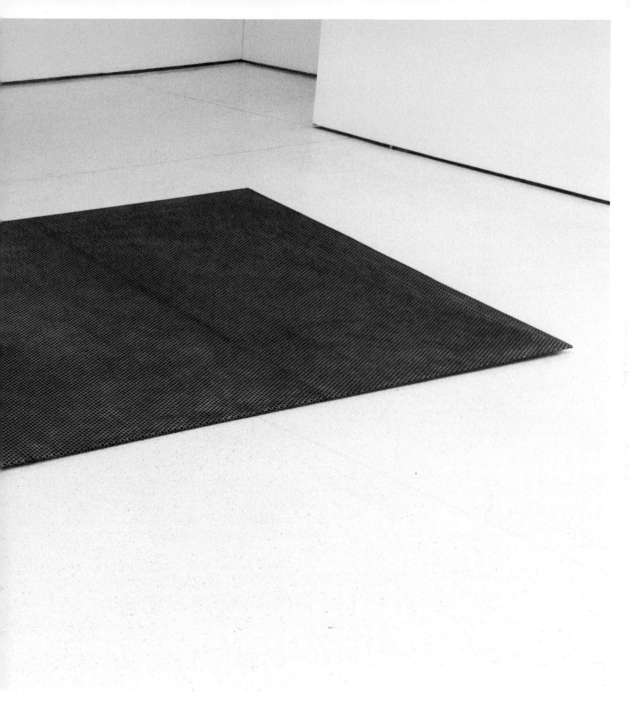

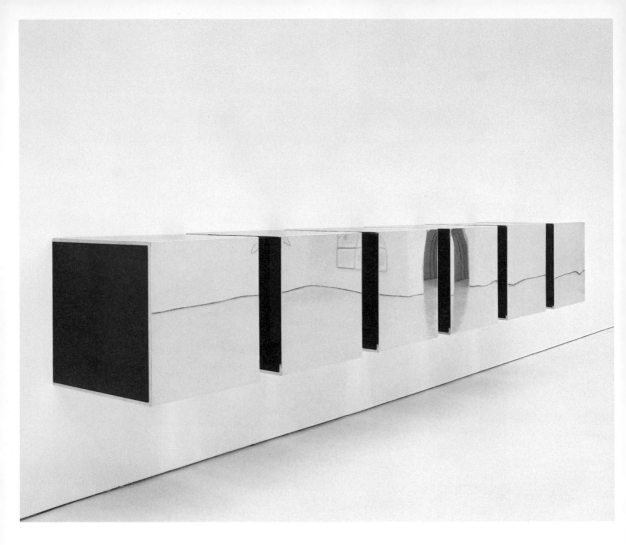

104

Donald Judd
Untitled, February 1, 1973

Brass and red fluorescent Plexiglas,
six units with 8-inch intervals
Overall: 34 x 244 x 34 inches
(86.4 x 619.8 x 86.4 cm)

Solomon R. Guggenheim Museum,
New York. Panza Collection
91.3719

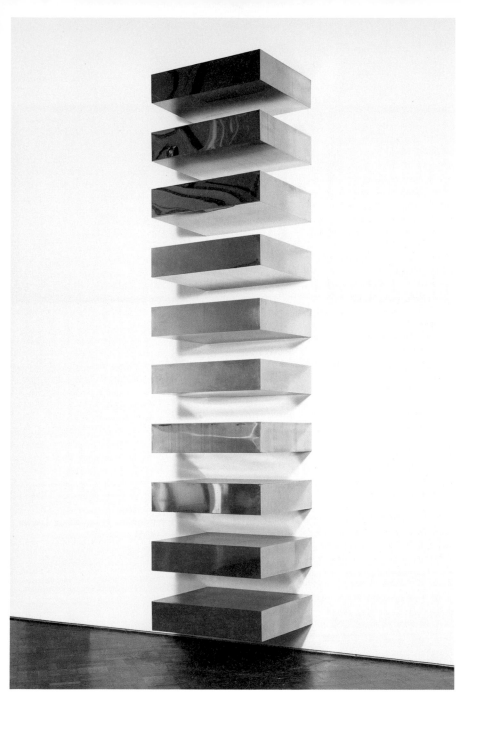

Donald Judd
Untitled, December 23, 1969

Copper, ten units with 9-inch intervals
Overall: 171 x 40 x 31 inches
(434.3 x 101.6 x 78.7 cm)

Solomon R. Guggenheim Museum,
New York. Panza Collection
91.3713

Jo Baer
Horizontals Flanking, Large,
Green Line, 1966

Oil and acrylic on canvas, two panels
Each: 60 x 84 inches
(152.4 x 213.4 cm)

Solomon R. Guggenheim Museum,
New York
68.1874

Robert Mangold
Neutral Pink Area, 1966

Oil on Masonite, two panels
Overall: 48 x 96 inches
(121.9 x 243.8 cm)

Solomon R. Guggenheim Museum,
New York. Panza Collection
91.3759

108

Gerhard Richter
Passage (Durchgang), 1968

Oil on canvas
78 3/4 x 78 3/4 inches (200 x 200 cm)

Solomon R. Guggenheim Museum,
New York. Gift, The Theodoron Foundation
69.1904

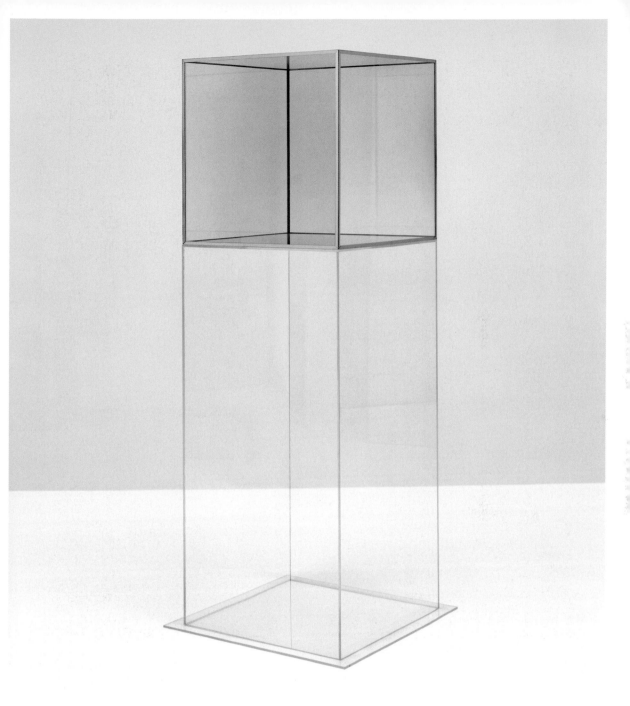

Larry Bell
20" Untitled 1969 (*Tom Messer Cube*), 1969

Glass and stainless steel
40 5/8 x 20 1/4 x 20 1/4 inches
(103.1 x 51.4 x 51.4 cm)

Solomon R. Guggenheim Museum, New
York. Gift, American Art Foundation
77.2318

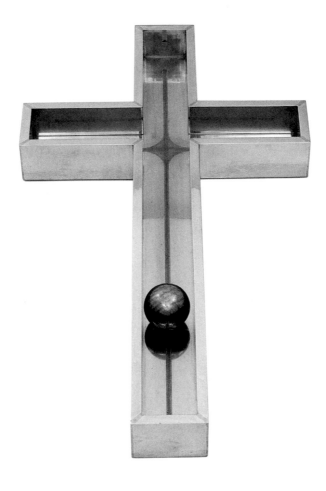

110

Walter De Maria
Cross, 1965–66

Aluminum
4 x 42 x 22 inches
(10.2 x 106.7 x 55.9 cm)

Solomon R. Guggenheim Museum,
New York
73.2033

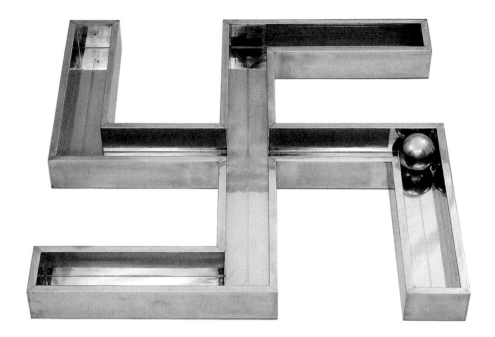

Walter De Maria
Museum Piece, 1966

Aluminum
4 x 36 x 36 inches
(10.2 x 91.5 x 91.5 cm)

Solomon R. Guggenheim Museum,
New York
73.2034

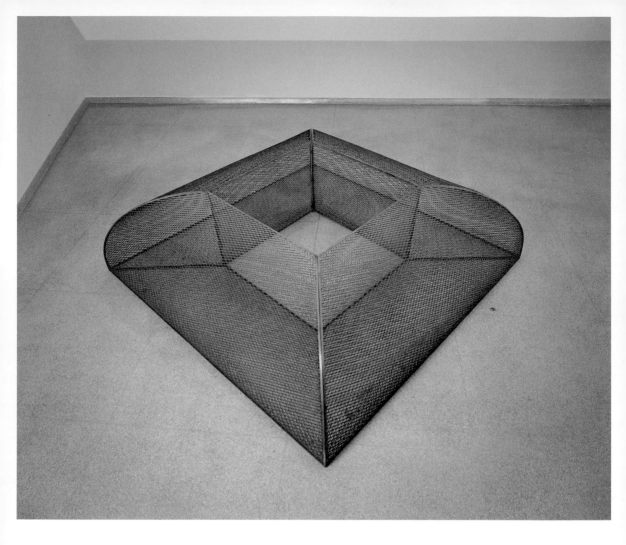

Robert Morris
Untitled (Quarter-Round Mesh), 1967

Steel grating
31 x 109 x 109 inches
(79 x 277 x 277 cm)

Solomon R. Guggenheim Museum,
New York. Panza Collection
91.3799

114

Robert Ryman
Surface Veil I, 1970

Oil and blue chalk on stretched
linen canvas
143 15/16 x 144 inches
(365.6 x 365.8 cm)

Solomon R. Guggenheim Museum,
New York. Panza Collection
91.3851

116

John McCracken
Blue Plank, 1969

Polyester resin on fiberglass and
plywood
94 1/2 x 22 1/4 x 3 1/8 inches
(239.4 x 56.5 x 8 cm)

Solomon R. Guggenheim Museum,
New York. Gift, Robert Elkon, New York
70.1934

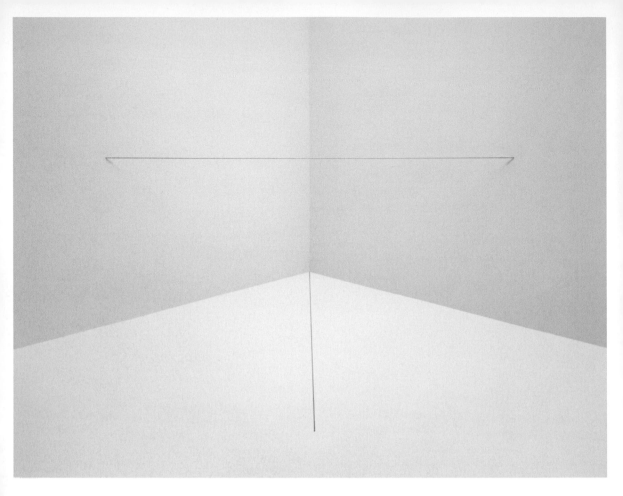

118

Fred Sandback
Pink Corner Piece, 1970

Two elastic cords, each 1/4-inch diameter
Overall, installed: 48 x 84 x 84 inches
(121.9 x 213.4 x 213.4 cm)

Solomon R. Guggenheim Museum,
New York. Gift, Virginia Dwan
94.4263

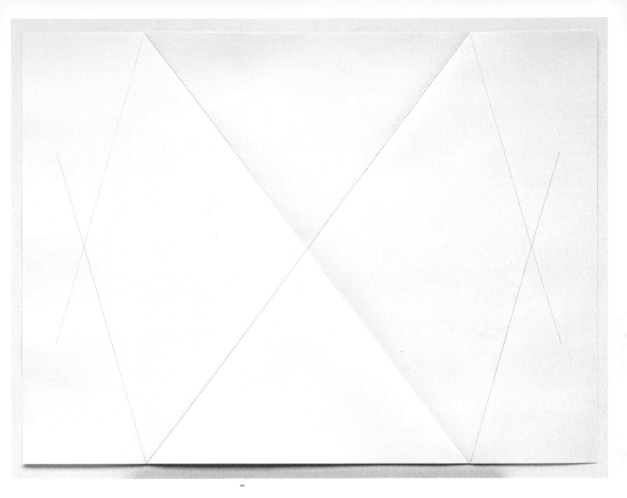

Dorothea Rockburne
A Drawing Which Makes Itself, 1972

Pencil on paper
29 3/4 x 39 1/2 inches (75.5 x 100.4 cm)

Solomon R. Guggenheim Museum,
New York. Gift, Leon Hecht
81.2879

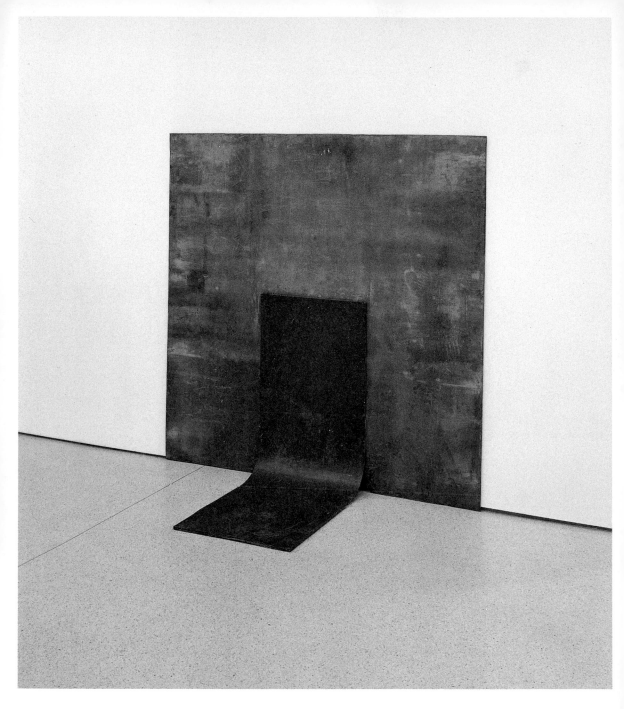

120

Richard Serra
Right Angle Prop, 1969

Lead antimony
72 x 72 x 34 inches
(182.9 x 182.9 x 86.4 cm)

Solomon R. Guggenheim Museum,
New York. Purchased with funds
contributed by The Theodoron Foundation
69.1906

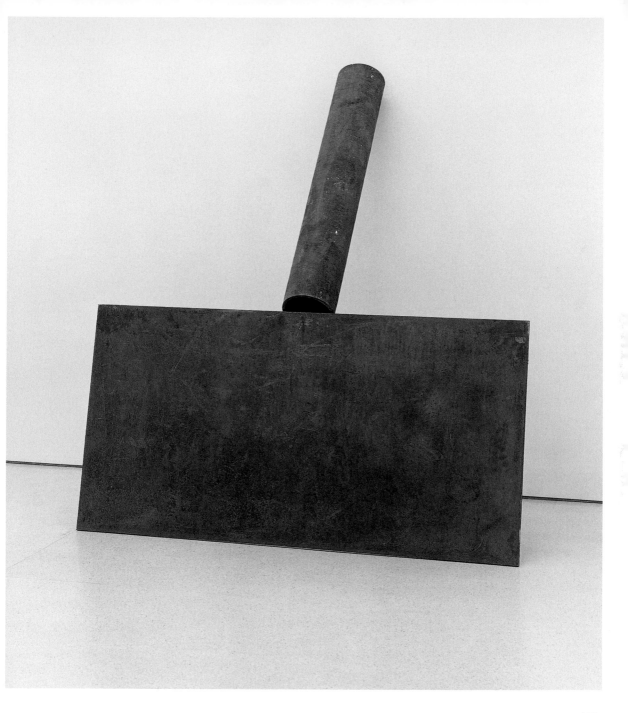

Richard Serra
Shovel Plate Prop, 1969

Steel, two units
Overall: 80 x 84 x 32 inches
(203 x 213.4 x 81.3 cm)

Solomon R. Guggenheim Museum,
New York. Panza Collection
91.3867

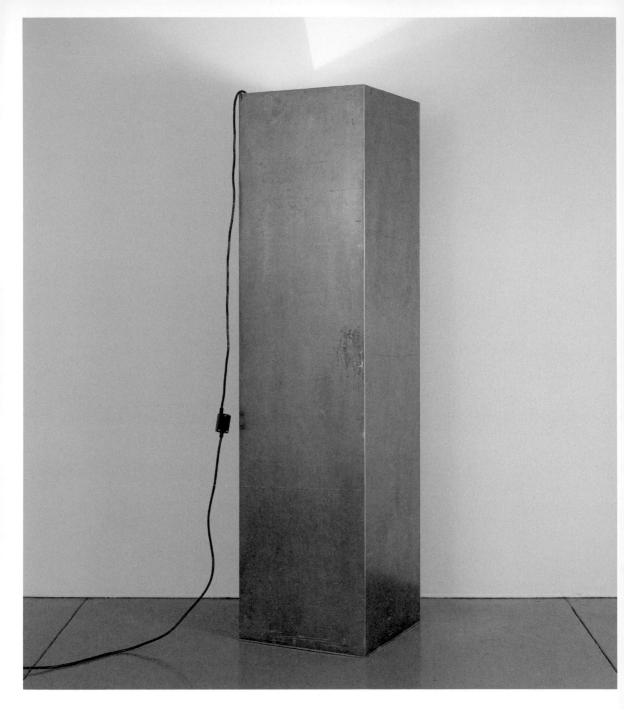

122

Bruce Nauman
Lighted Performance Box, 1969

Aluminum and 1,000-watt spotlight
78 x 20 x 20 inches
(198.1 x 50.8 x 50.8 cm)

Solomon R. Guggenheim Museum,
New York. Panza Collection
91.3820

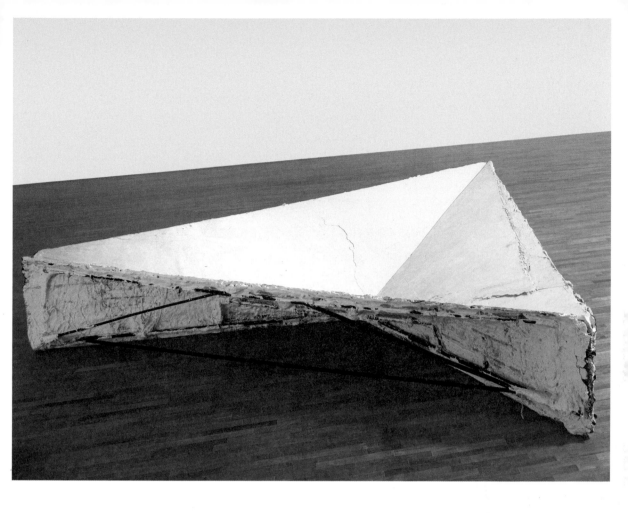

Bruce Nauman
Triangular Depression, 1977

Plaster, burlap, steel mesh, and steel rods
21 x 121 x 103 inches
(53.3 x 307.3 x 261.6 cm)

The Museum of Modern Art, New York, Gift
of Werner and Elaine Dannheisser, 1996;
Solomon R. Guggenheim Museum,
New York, Fractional gift, Werner Division
91.3901

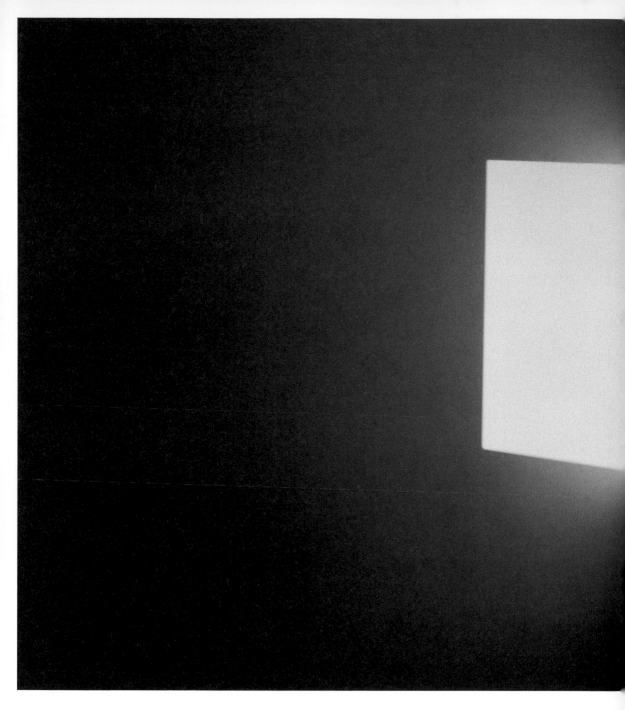

124

James Turrell
Afrum I, 1967

MSR lamp projection, 1,200 watts
Dimensions variable

Solomon R. Guggenheim Museum,
New York. Panza Collection, Gift
92.4175

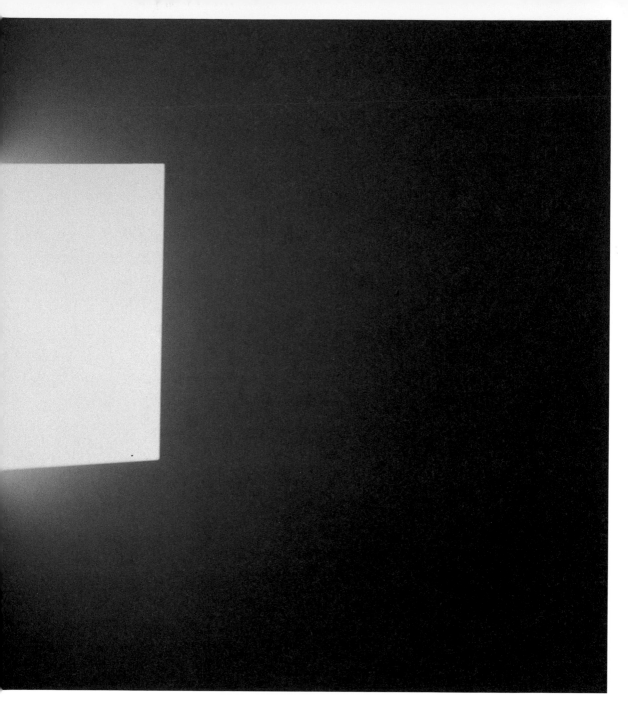

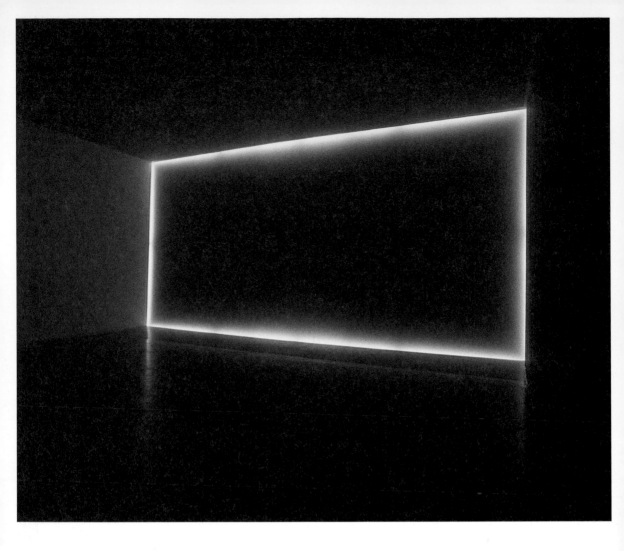

126

Doug Wheeler
Untitled (Environmental Light),
Los Angeles, 1969–70

Installation with neon
Dimensions site-specific
Dimensions of original installation at
Ace Gallery, Los Angeles: 624 x 252 x 297
inches (1,585 x 640 x 754 cm)

Solomon R. Guggenheim Museum,
New York. Panza Collection, Gift
91.4086

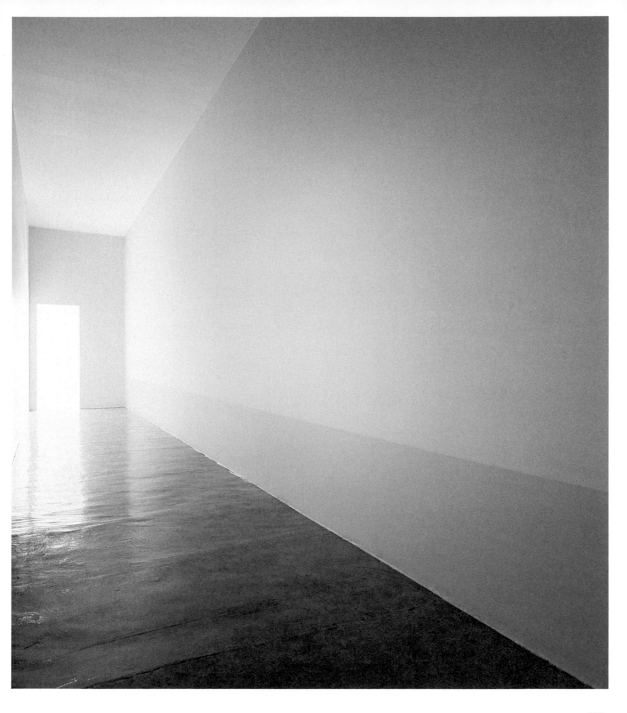

Robert Irwin
Varese Scrim, 1973

Nylon scrim
Dimensions site-determined; room:
150 3/8 x 563 x 72 1/16 inches
(382 x 1430 x 183 cm); scrim:
150 3/8 x 563 inches (382 x 1430 cm)

Solomon R. Guggenheim Museum,
New York. Panza Collection, Gift,
on permanent loan to Fondo per
l'Ambiente Italiano
92.4134

128

Roman Opalka
1965/ 1-∞; *Detail-1,520,432 - 1,537,871,*
1965

Acrylic on canvas, with audio recording
77 1/4 x 53 1/4 inches
(196.2 x 135.2 cm)

Solomon R. Guggenheim Museum,
New York
76.2220

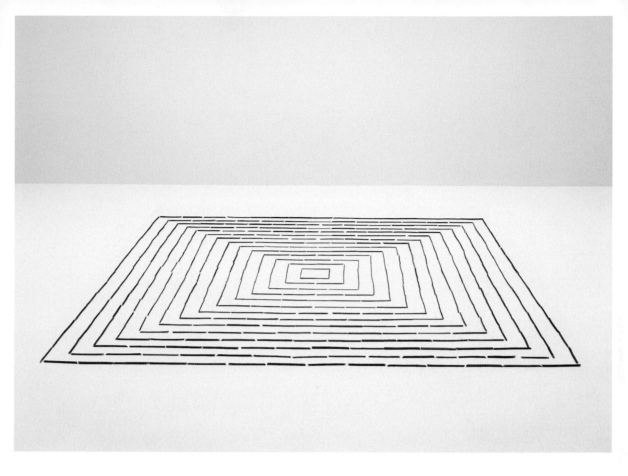

129

Richard Long
Untitled, 1967

Twigs, 420 units
Overall: approximately 85 13/16 x 84 7/8
inches (218 x 215.5 cm)

Solomon R. Guggenheim Museum,
New York. Panza Collection
91.3749

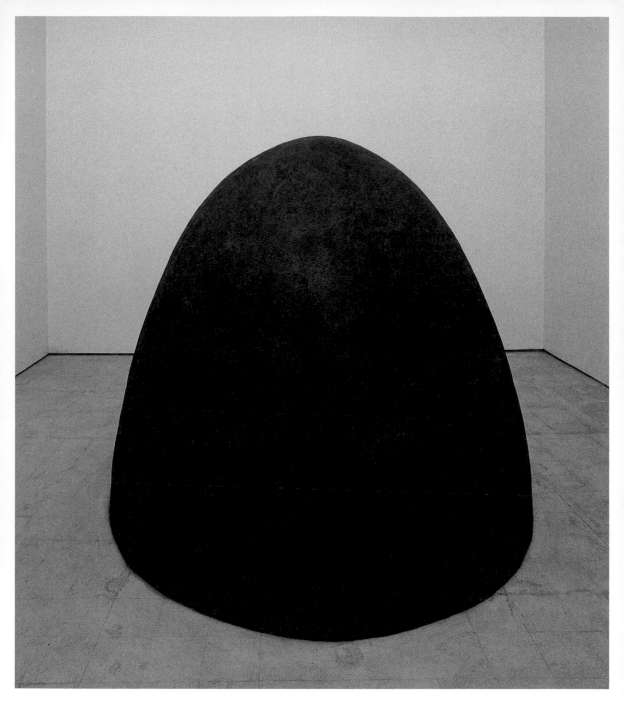

130

Jene Highstein
Black Elliptical Cone, Varese, 1976

Wood armature, wire mesh, and black
cement or stucco painted black
Base diameters: 90 1/2 inches (229.9 cm)
and 99 5/8 inches (253 cm);
height: 76 3/4 inches (194.9 cm)

Solomon R. Guggenheim Museum,
New York. Panza Collection, Gift
92.4124

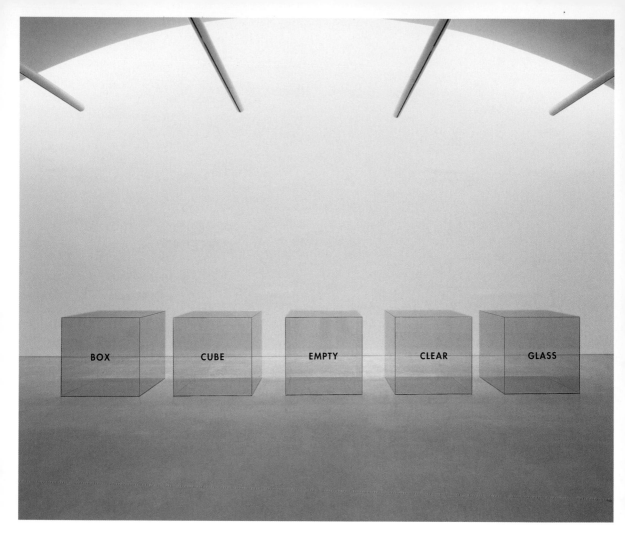

Joseph Kosuth
Box, Cube, Empty, Clear, Glass—
A Description, 1965

Five glass cubes with
silkscreened lettering
Each: 40 x 40 x 40 inches
(101.6 x 101.6 x 101.6 cm)

The Panza Collection

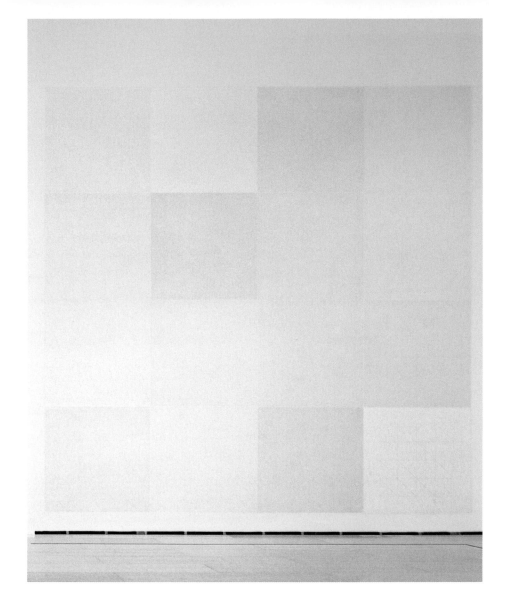

Sol LeWitt
Wall Drawing #262. All one-, two-,
three-, and four-part combinations of lines
in four directions and four colors each
within a square. Fifteen drawings.

First installed: July 1975, Villa Menafoglio
Litta Panza, Varese

Colored pencil, site-specific dimensions

Solomon R. Guggenheim Museum,
New York. Panza Collection, Gift
92.4155

TO SEE & BE SEEN

Lawrence Weiner
Cat. #278 (1972)
TO SEE AND BE SEEN, 1972

Language and the materials referred to
Dimensions variable

Solomon R. Guggenheim Museum,
New York. Panza Collection, Gift
92.4193

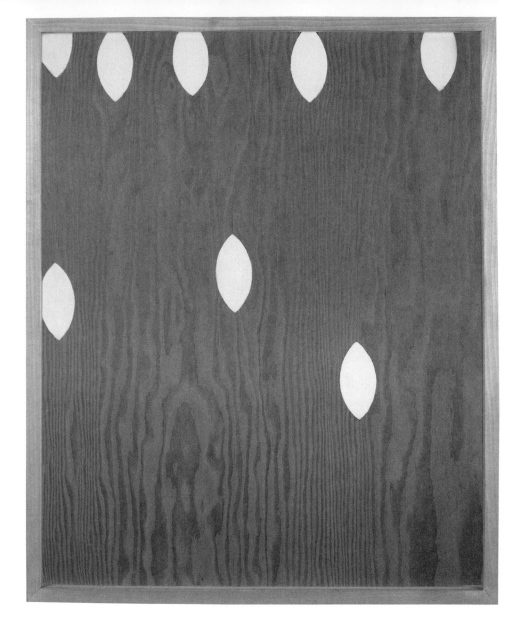

Sherrie Levine
White Knot: 9, 1986

Casein on plywood
31 1/4 x 21 1/4 inches (79.4 x 61.6 cm)

Courtesy Paula Cooper Gallery, New York

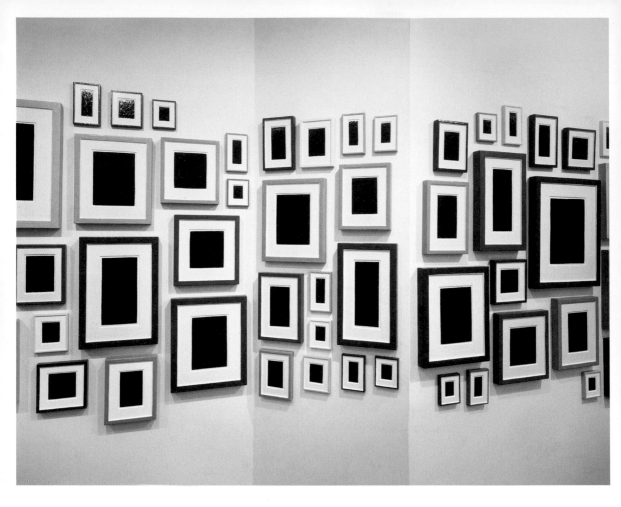

136

Allan McCollum Enamel on solid-cast Hydrostone Courtesy of the artist
Plaster Surrogates, 1982/84 Overall dimensions variable

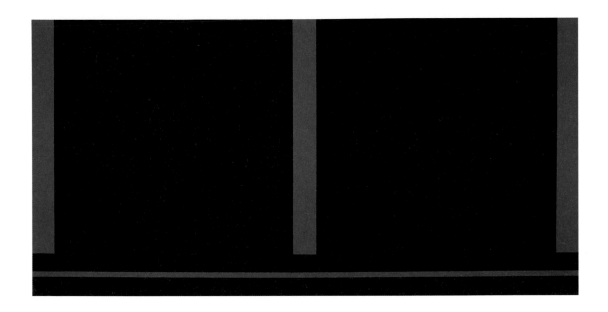

Peter Halley
Two Cells with Conduit, 1987

Day-Glo, acrylic, and Roll-a-Tex on canvas,
two panels
Overall: 78 5/8 x 155 1/8 inches
(199.7 x 394 cm)

Solomon R. Guggenheim Museum,
New York. Purchased with funds
contributed by Denise and Andrew Saul
and Ellyn and Saul Dennison
87.3550

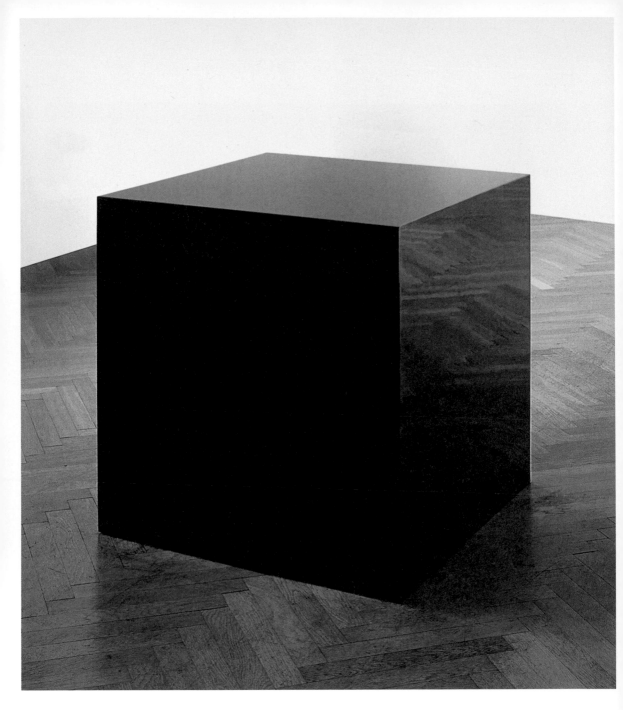

138

Charles Ray
Ink Box, 1986

Automobile paint on steel with
printer's ink
36 1/4 x 36 1/4 x 36 1/4 inches
(92.1 x 92.1 x 92.1 cm)

Collection of the Orange County Museum of
Art, Newport Beach, Calif.; Museum
purchase with additional funds provided by
Edward R. Broida

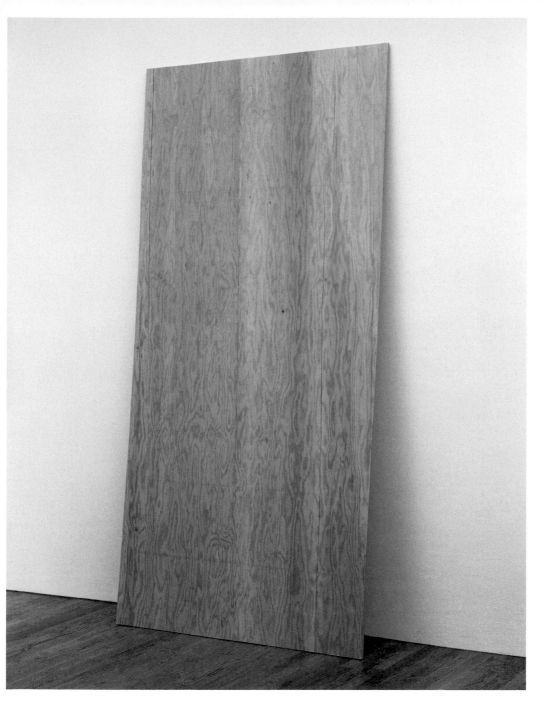

Robert Gober
Plywood, 1987

Laminated fir
95 1/2 x 46 1/2 x 5/8 inches
(242.6 x 118.1 x 1.6 cm)

Collection of Andrew Ong

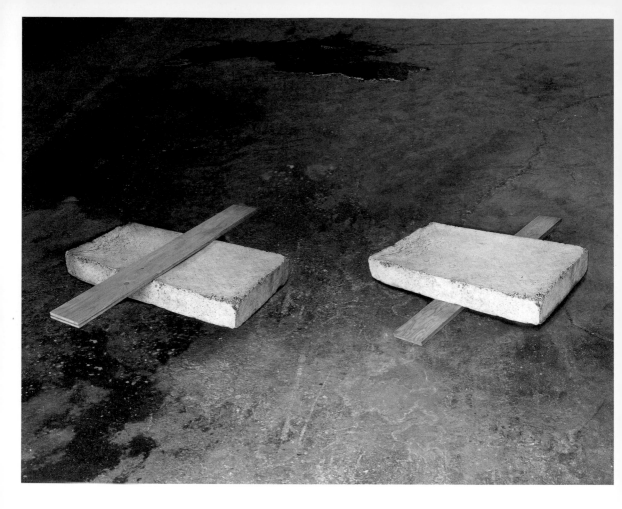

140

Robert Gober
Untitled, 2000–01

Bronze, paint, and fir, two units
Each: 7 x 68 x 47 1/4 inches
(17.8 x 172.7 x 120cm)

Collection Kathy and Keith Sachs, Courtesy
Matthew Marks Gallery, New York

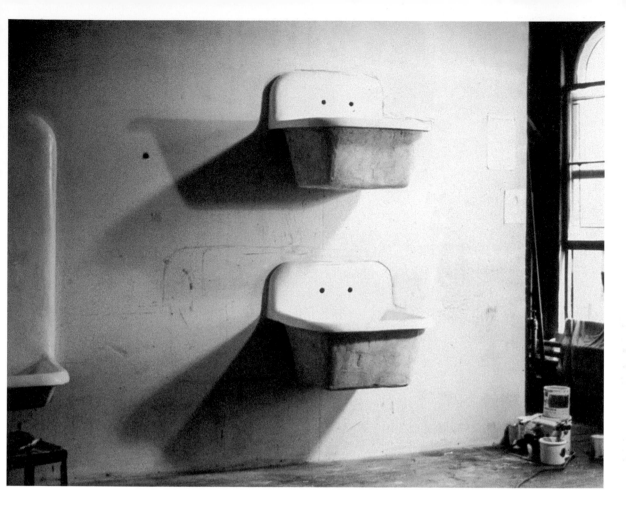

Robert Gober
The Ascending Sink, 1985

Two sinks: plaster, wood, steel,
wire lath, and semigloss enamel paint
Each: 30 x 38 x 27 inches
(76.2 x 96.5 x 68.6 cm)

Collection Thea Westreich and Ethan
Wagner, New York

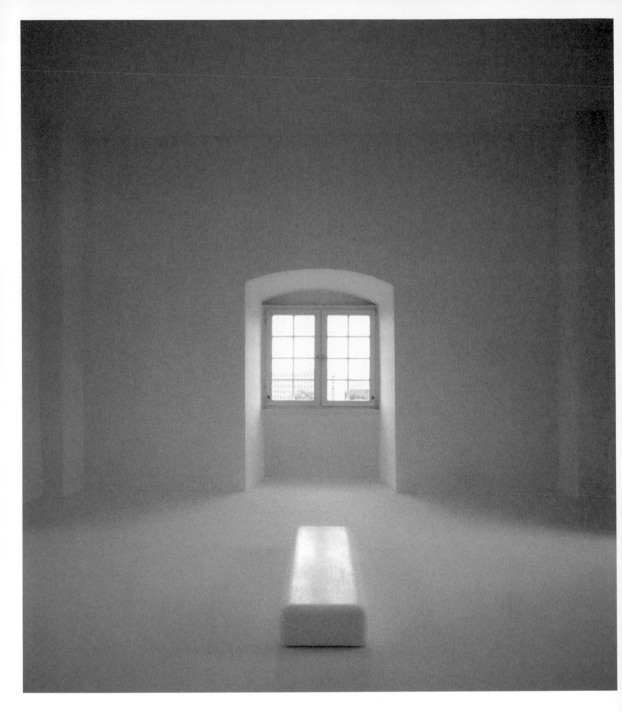

142

James Lee Byars
The White Figure, 1990

Kavala marble
7 7/8 x 17 11/16 x 66 15/16 inches
(20 x 45 x 170 cm)

Courtesy Michael Werner Gallery,
New York and Cologne

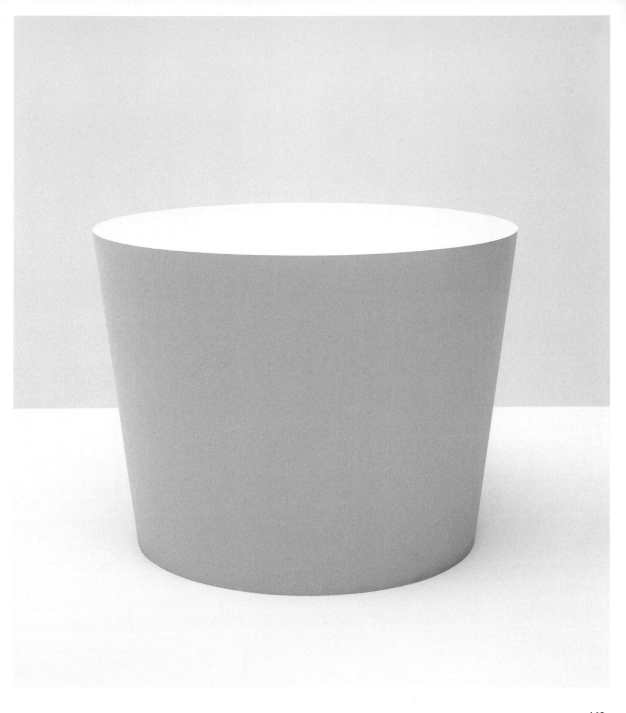

143

Ettore Spalletti
Vaso, 1981–92

Paint on wood
Height: 49 3/16 inches (125 cm);
diameter, maximum: 39 3/8 inches (100 cm),
minimum: 35 7/16 inches (90 cm)

Solomon R. Guggenheim Museum,
New York. Gift of the artist
93.4242

Karin Sander
Wallpiece, 1995

Polished wall paint
86 5/8 x 330 3/4 inches (220 x 840 cm)

Collection Staatsgalerie Stuttgart

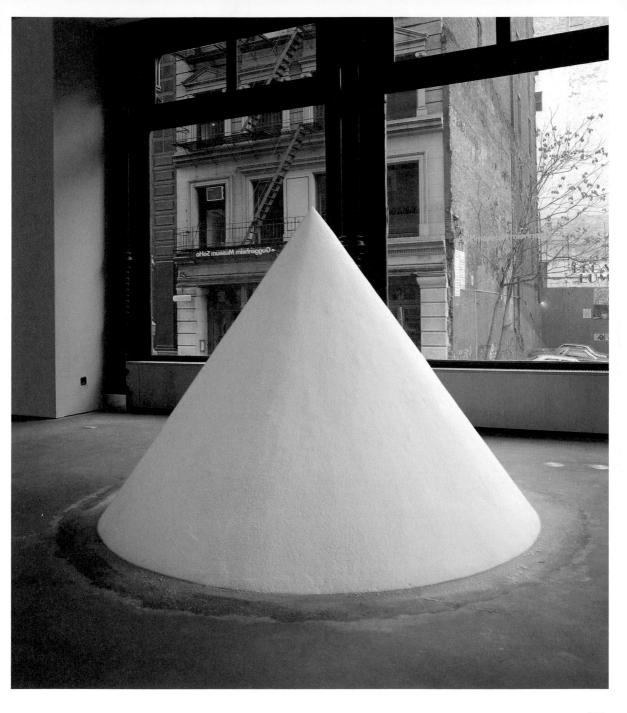

145

Meg Webster
Cono di Sale, June 1988

Salt
Height: 72 inches (182.9 cm);
diameter: 96 inches (243.8 cm)

Solomon R. Guggenheim Museum,
New York, Panza Collection, Gift
92.4082

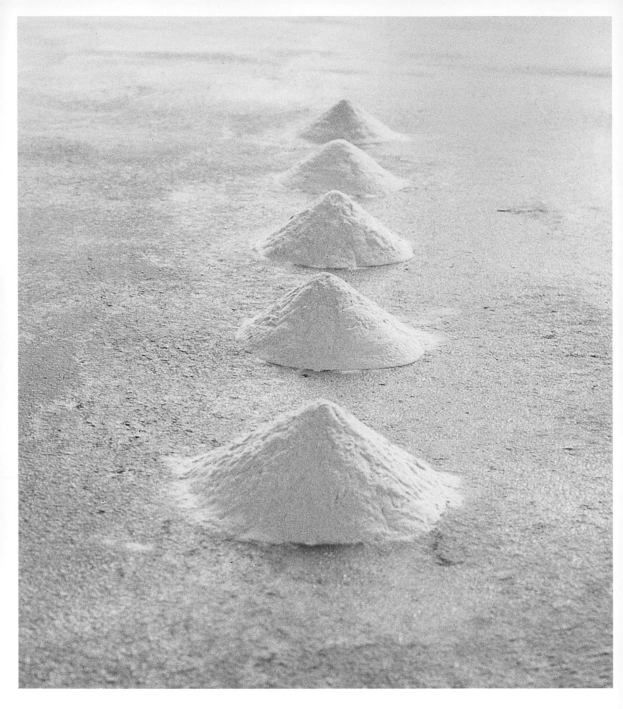

146

Wolfgang Laib
The Five Mountains not to Climb On
(*Die fünf unbesteigbaren Berge*), 1984

Hazelnut pollen
Height: approximately 2 3/4 inches
(7 cm)

Collection of the artist

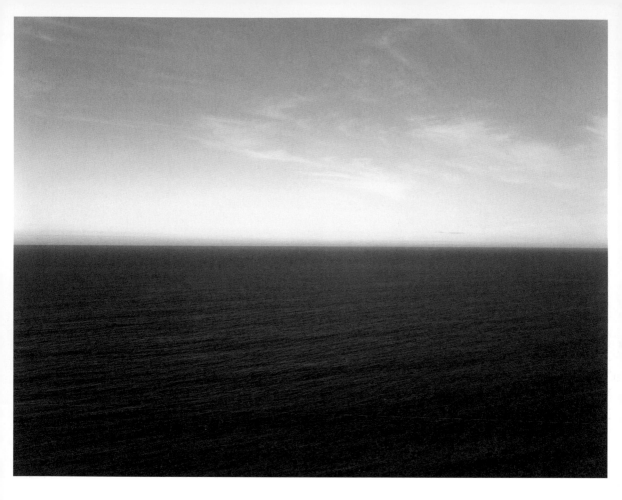

148

Hiroshi Sugimoto
Tasman Sea, Ngarupupu, 1990

Black-and-white photograph
Edition 5/25
20 x 24 inches (50.8 x 61.0 cm)

Solomon R. Guggenheim Museum,
New York. Partial and promised gift,
The Bohen Foundation
2001.268

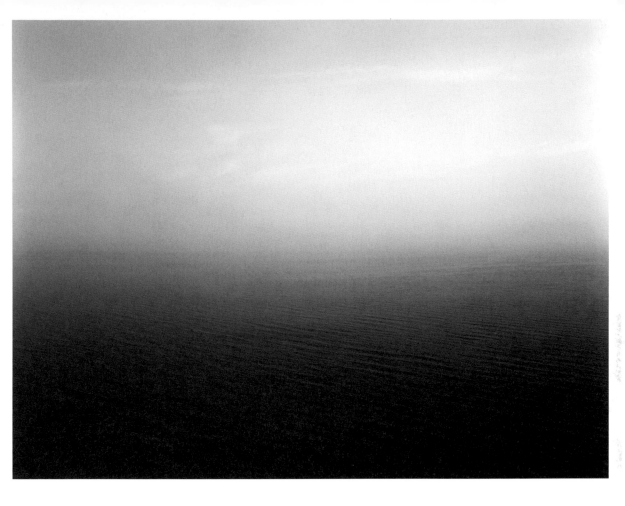

Hiroshi Sugimoto
Black Sea, Ozuluce, 1991

Black-and-white photograph
Edition 14/25
20 x 24 inches (50.8 x 61.0 cm)

Solomon R. Guggenheim Museum,
New York. Partial and promised gift,
The Bohen Foundation
2001.270

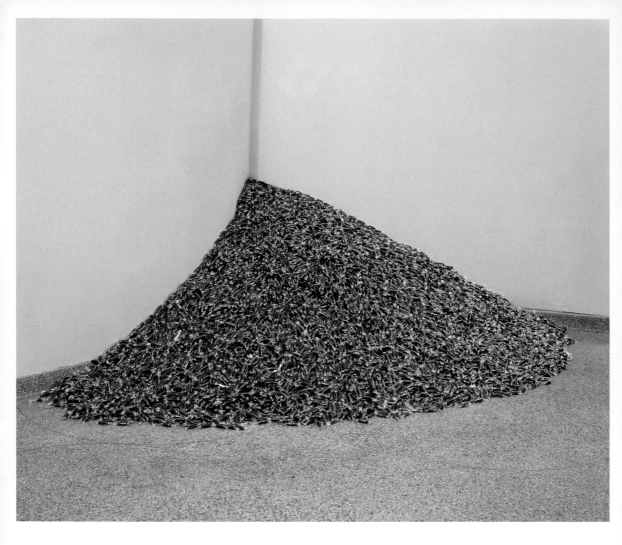

150

Felix Gonzalez-Torres
"Untitled" (Public Opinion), 1991

Black rod licorice candy, individually
wrapped in cellophane (endless supply);
Ideal weight: 700 pounds
Dimensions variable

Solomon R. Guggenheim Museum,
New York. Purchased with funds
contributed by the Louis and Bessie Adler
Foundation, Inc., and the

National Endowment for the Arts
Museum Purchase Program
91.3969

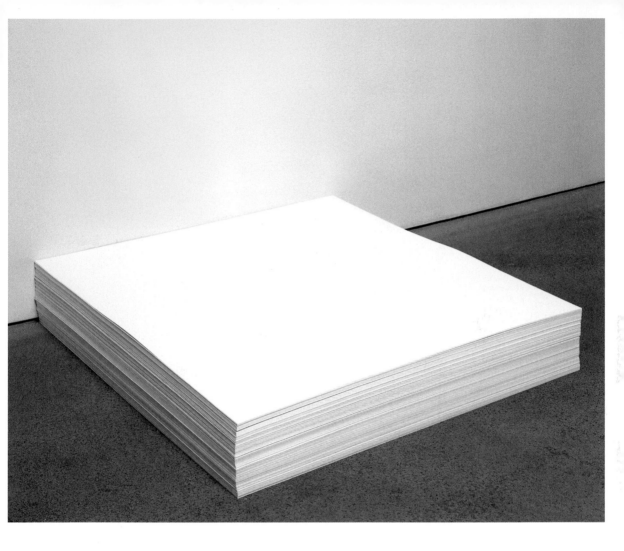

Felix Gonzalez-Torres
"Untitled" (Passport), 1991

Paper, endless copies
4 inches (10.2 cm) at ideal height
23 5/8 x 23 5/8 inches (60 x 60 cm)

Marieluise Hessel Collection on permanent
loan to the Center for Curatorial Studies,
Bard College, Annandale-on-Hudson,
New York

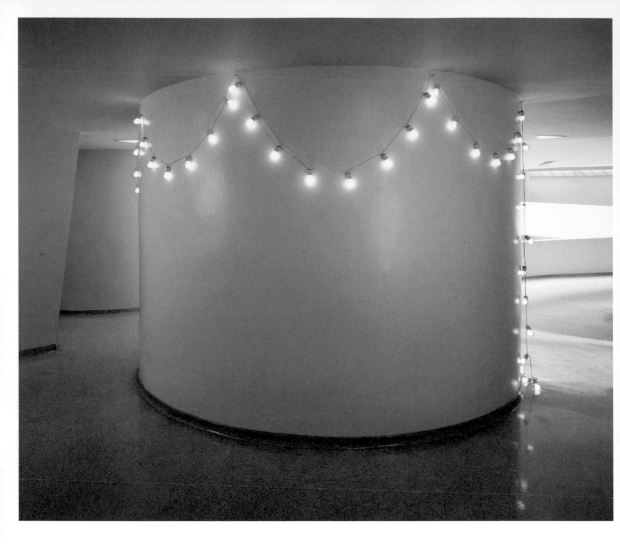

Felix Gonzalez-Torres
"Untitled" (America #1), 1992

Fifteen-watt lightbulbs, porcelain light
sockets, extension cord
Overall dimensions vary with installation
42 feet (12.8 m) length, with 20 feet (6 m)
extra cord

The Carol and Arthur Goldberg
Collection

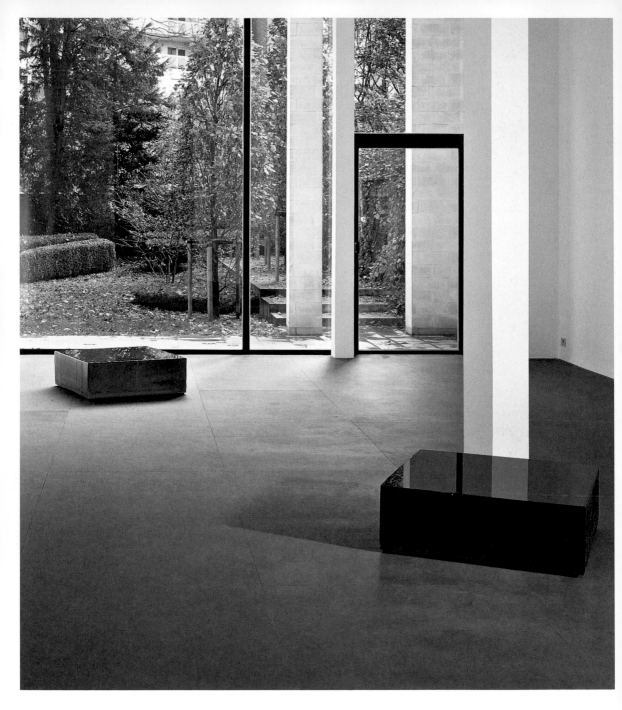

Roni Horn
Untitled (Flannery), 1996–97

Optically clear blue glass, two units
Edition 1/3
Each: 11 x 33 x 33 inches
(27.94 x 83.82 x 83.82 cm)

Solomon R. Guggenheim Museum, New
York. Purchased with funds contributed by
the International Director's Council and
Executive Committee Members: Edythe
Broad, Elaine Terner Cooper, Linda
Fischbach, Ronnie Heyman, J. Tomilson
Hill, Dakis Joannou, Barbara Lane,

Peter Norton, Willem Peppler, Alain-
Dominique Perrin, David Teiger,
Ginny Williams, and Elliot Wolk
98.4624

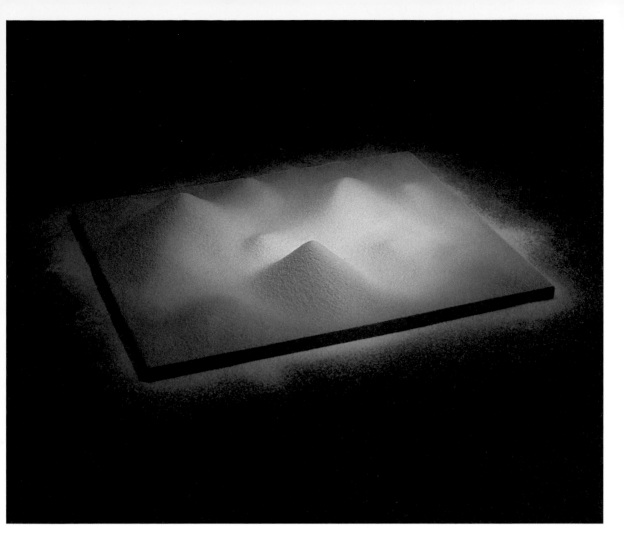

155

Koo Jeong-a
Oslo, 1998

Crushed aspirin, wood, and blue light
Dimensions variable

Solomon R. Guggenheim Museum,
New York. Purchased with funds contributed
by the Young Collectors Council
2003.62

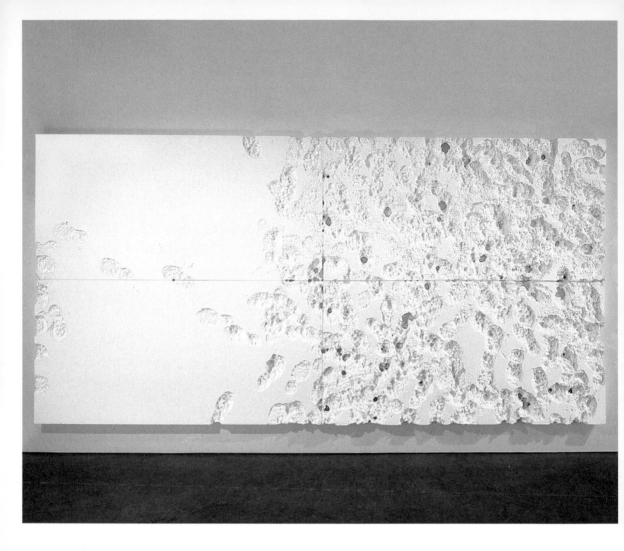

Rudolf Stingel
untitled, 2000

Styrofoam, four panels
Overall: 96 x 192 x 4 inches (240 x 480 x 10 cm); each panel: 48 x 96 x 4 inches (120 x 240 x 10 cm)

Courtesy the artist and Paula Cooper Gallery, New York

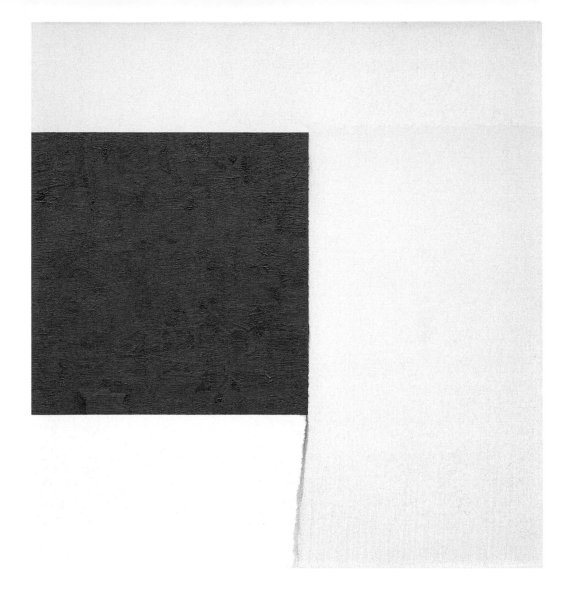

Callum Innes
Exposed Painting, Bluish Grey/Pewter on White, 1998

Oil on linen
30 1/2 x 28 1/2 inches (77.5 x 72.4 cm)

Solomon R. Guggenheim Museum, New York. Partial and promised gift, The Bohen Foundation
2001.132

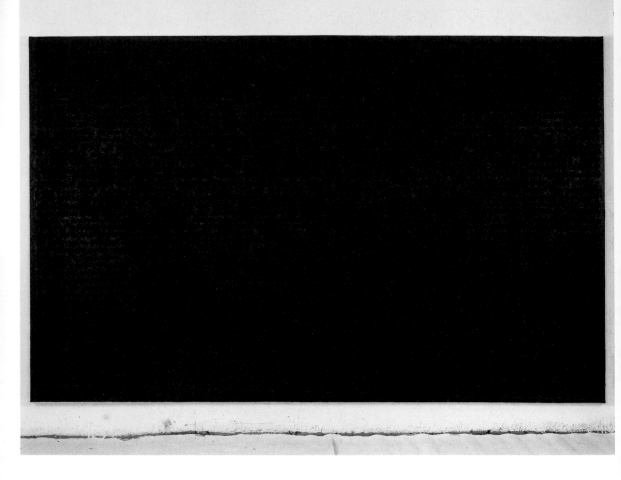

Glenn Ligon
Untitled, 2002

Coal dust, printing ink, oil stick, glue,
acrylic paint, and gesso on canvas
74 7/8 x 118 1/8 inches (190 x 300 cm)

Courtesy of the artist and D'Amelio Terras,
New York

159

Damien Hirst
Armageddon, 2002

House flies on canvas
144 x 108 inches (365.8 x 274.3 cm)

Private collection

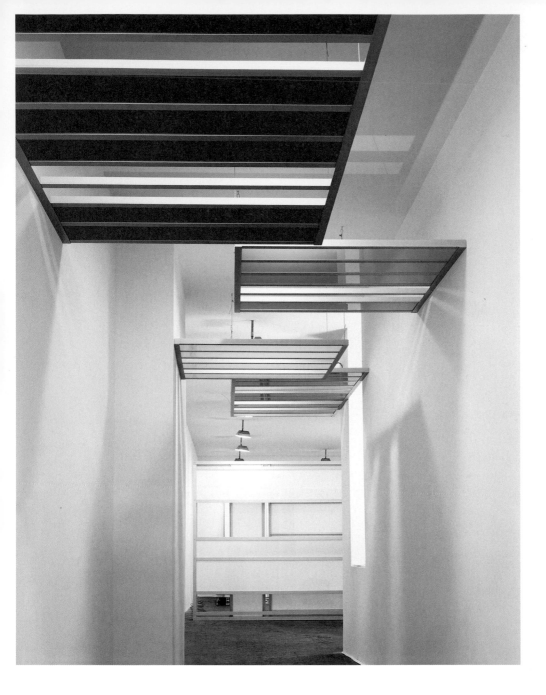

Liam Gillick
Trajectory Platform, 2000

Anodized aluminum and red
opaque Plexiglas
48 x 96 x 1 1/2 inches
(121.9 x 243.8 x 3.8 cm);
height variable

Solomon R. Guggenheim Museum,
New York. Purchased with funds contri-
buted by the Young Collectors Council
2001.28

Installation view,
work in foreground

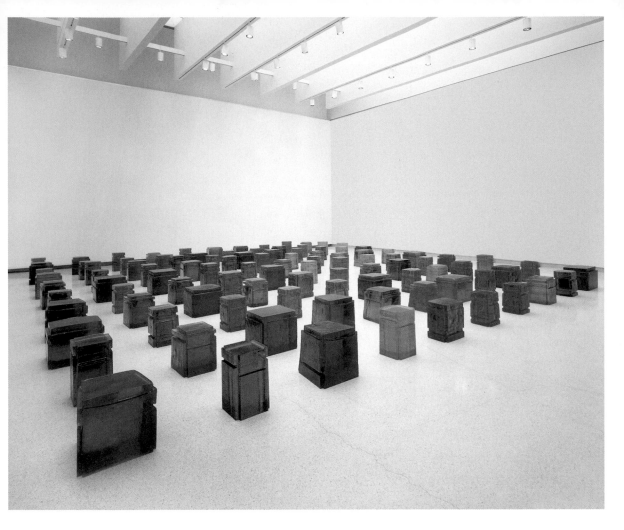

Rachel Whiteread
Untitled (One Hundred Spaces), 1995

Resin, 100 units
Overall dimensions variable

Courtesy Anthony d'Offay Gallery, London

Works in the Exhibition

Carl Andre (b. 1935)
5 x 20 Altstadt Rectangle, Düsseldorf, 1967
Hot-rolled steel, 100 units
Overall: 3/16 x 98 1/2 x 394 inches
(0.5 x 250 x 1000 cm)
Solomon R. Guggenheim Museum,
New York
Panza Collection
91.3667

Carl Andre
Fall, New York, 1968
Hot-rolled steel, twenty-one L-shaped units
Overall: 72 x 588 x 72 inches (182.9 x 1493.5
x 182.9 cm)
Solomon R. Guggenheim Museum,
New York
Panza Collection
91.3670

Carl Andre
Zinc Ribbon, Antwerp, 1969
Zinc, one continuous strip
1/16 x 3 9/16 x 826 3/4 inches
(0.1 x 9 x 2100 cm)
Solomon R. Guggenheim Museum,
New York
Panza Collection
91.3672

Carl Andre
Herm (Element Series), 1976
Western Red Cedar
36 x 11 3/4 x 11 1/2 inches
(91.3 x 29.7 x 29.2 cm)
Solomon R. Guggenheim Museum,
New York
Gift, Angela Westwater
86.3440

Carl Andre
Trabum, 1977
Douglas fir, nine units
Overall: 36 x 36 x 36 inches
(91.4 x 91.4 x 91.4 cm)
Solomon R. Guggenheim Museum,
New York
Purchased with funds contributed by the
National Endowment for the Arts in
Washington, D.C., a Federal Agency;
matching funds donated by Mr. and Mrs.
Donald Jonas
78.2519

Jo Baer (b. 1929)
Horizontals Flanking, Large, Green Line,
1966
Oil and acrylic on canvas, two panels
Each: 60 x 84 inches
(152.4 x 213.4 cm)
Solomon R. Guggenheim Museum,
New York
68.1874

Larry Bell (b. 1939)
20" Untitled 1969 (Tom Messer Cube), 1969
Glass and stainless steel
40 5/8 x 20 1/4 x 20 1/4 inches
(103.1 x 51.4 x 51.4 cm)
Solomon R. Guggenheim Museum,
New York
Gift, American Art Foundation
77.2318

James Lee Byars (1932–1997)
The White Figure, 1992
Kavala marble
7 7/8 x 17 11/16 x 66 15/16 inches
(20 x 45 x 170 cm)
Courtesy Michael Werner Gallery,
New York and Cologne

James Lee Byars
The Figure 8, 1994
Kavala marble
7 7/8 x 23 1/4 x 43 11/16 inches
(20 x 59 x 111 cm)
Courtesy Michael Werner Gallery,
New York and Cologne

Walter De Maria (b. 1935)
Cross, 1965–66
Aluminum
4 x 42 x 22 inches (10.2 x 106.7 x 55.9 cm)
Solomon R. Guggenheim Museum,
New York
73.2033

Walter De Maria
Museum Piece, 1966
Aluminum
4 x 36 x 36 inches
(10.2 x 91.5 x 91.5 cm)
Solomon R. Guggenheim Museum,
New York
73.2034

Walter De Maria
Star, 1972
Aluminum
4 x 44 x 50 inches
(10.2 x 111.8 x 127 cm)
Solomon R. Guggenheim Museum,
New York
73.2035

Dan Flavin (1933–1996)
the nominal three (to William of Ockham),
1963
Fluorescent light fixtures with
daylight lamps
Edition 2/3
Height: 72 inches (183 cm);
Overall dimensions variable
Solomon R. Guggenheim Museum,
New York
Panza Collection
91.3698

Dan Flavin
untitled, 1964
Fluorescent light fixtures with cool white
deluxe lamps
Edition 1/3
Overall: 4 x 133 1/2 x 84 3/4 inches
(10.2 x 339.1 x 215.3 cm)
Solomon R. Guggenheim Museum,
New York
Panza Collection
91.3700

Liam Gillick (b. 1964)
Trajectory Platform, 2000
Anodized aluminum and red opaque
Plexiglas
48 x 96 x 1 1/2 inches
(121.9 x 243.8 x 3.8 cm); height variable
Solomon R. Guggenheim Museum,
New York
Purchased with funds contributed by the
Young Collectors Council
2001.28

Liam Gillick
56th Floor Structure, 2004
Aluminum with black powder coating
96 x 96 x 96 inches
(243.8 x 243.8 x 243. cm)
Courtesy Casey Kaplan, New York

Robert Gober (b. 1954)
Untitled, ca. 1984
Plaster, wire, lath, wood, and semigloss
enamel paint
18 1/2 x 30 1/4 x 26 1/2 inches (47 x 77 x
67.5 cm)
Collection of the artist

Robert Gober
The Ascending Sink, 1985
Two sinks: plaster, wood, steel, wire lath,
and semigloss enamel paint
Each: 30 x 33 x 27 inches
(76.2 x 83.8 x 68.6 cm)
Collection Thea Westreich and Ethan
Wagner, New York

Robert Gober
Untitled, 1986
Graphite and latex paint on paper
11 x 14 inches (27.9 x 35.6 cm)
Private Collection, Courtesy of Edward
Boyer Associates

Robert Gober
Untitled, 1987
Graphite on paper
11 x 14 inches (27.9 x 35.6 cm)
Collection of Barbara Goldfarb, New York

Robert Gober
Plywood, 1987
Laminated fir
94 3/4 x 47 x 5/8 inches
(240.7 x 119.4 x 1.6 cm)
Collection of Andrew Ong

Robert Gober
Untitled, 2000–01
Bronze, paint, and fir, two units
Each: 7 x 68 x 47 1/4 inches
(17.8 x 172.7 x 120cm)
Collection Kathy and Keith Sachs, Courtesy
Matthew Marks Gallery, New York

Felix Gonzalez-Torres (1957–1996)
"Untitled", 1987
Photostat, framed
Edition of 1 with 1 A.P. and 2 additional A.P.
8 1/4 x 10 1/4 inches (21 x 26 cm)
Courtesy of The Estate of Felix
Gonzalez-Torres

Felix Gonzalez-Torres
"Untitled", 1988
Photostat, framed
Edition of 3 with 1 A.P.
8 1/4 x 10 1/4 inches (21 x 26 cm)
Courtesy of The Estate of Felix
Gonzalez-Torres

Felix Gonzalez-Torres
"Untitled", 1988
Photostat, framed
Edition of 2 with 1 A.P.
8 1/4 x 10 1/4 inches (21 x 26 cm)
Courtesy of The Estate of Felix
Gonzalez-Torres

Felix Gonzalez-Torres
"Untitled" (Public Opinion), 1991
Black rod licorice candy, individually
wrapped in cellophane (endless supply);
Ideal weight: 700 pounds
Dimensions variable
Solomon R. Guggenheim Museum,
New York
Purchased with funds contributed by the
Louis and Bessie Adler Foundation, Inc.,
and the National Endowment for the Arts
Museum Purchase Program
91.3969

Felix Gonzalez-Torres
"Untitled" (Passport), 1991
White paper (endless copies)
4 (at ideal height) x 23 5/8 x 23 5/8 inches
(10.2 x 60 x 60 cm)
Marieluise Hessel Collection on permanent
loan to the Center for Curatorial Studies,
Bard College, Annandale-on-Hudson,
New York

Felix Gonzalez-Torres
"Untitled" (Leaves of Grass), 1993
15-watt light bulbs, porcelain light sockets,
extension cord
Overall dimensions vary with installation
length: 498 inches (1265 cm);
extra cord: 240 inches (610 cm)
Private Collection, New York

Peter Halley (b. 1953)
Two Cells with Conduit, 1987
Day-Glo, acrylic, and Roll-a-Tex on canvas,
two panels
Overall: 78 5/8 x 155 1/8 inches
(199.7 x 394 cm)
Solomon R. Guggenheim Museum,
New York
Purchased with funds contributed by
Denise and Andrew Saul and Ellyn and
Saul Dennison
87.3550

Jene Highstein (b. 1942)
Black Elliptical Cone, Varese, 1967
Wood armature, wire mesh, and stucco
painted black
Base diameters: 90 1/2 inches (229.9 cm)
and 99 5/8 inches (253 cm);
height: 76 3/4 inches (194.9 cm)
Solomon R. Guggenheim Museum,
New York
Panza Collection, Gift
92.4124

Damien Hirst (b. 1965)
Armageddon, 2002
House flies on canvas
144 x 108 inches (365.8 x 274.3 cm)
Private Collection

Roni Horn (b. 1955)
Untitled (Flannery), 1996–97
Optically clear blue glass, two units
Edition 1/3

Each: 11 x 33 x 33 inches
(27.94 x 83.82 x 83.82 cm)
Solomon R. Guggenheim Museum,
New York
Purchased with funds contributed by the
International Director's Council and
Executive Committee Members: Edythe
Broad, Elaine Terner Cooper, Linda
Fischbach, Ronnie Heyman, J. Tomilson Hill,
Dakis Joannou, Barbara Lane,
Peter Norton, Willem Peppler, Alain-
Dominique Perrin, David Teiger, Ginny
Williams, and Elliot Wolk
98.4624

Roni Horn
Untitled #1, 1998
Iris printed photograph on Somerset Satin
paper, two sheets
Edition of 15
Each: 22 x 22 inches (55.9 x 55.9 cm)
Courtesy of the artist and Matthew Marks
Gallery, New York

Callum Innes (b. 1962)
*Exposed Painting, Bluish Grey/
Pewter on White*, 1998
Oil on linen
30 1/2 x 28 1/2 inches
(77.5 x 72.4 cm)
Solomon R. Guggenheim Museum,
New York
Partial and promised gift, The Bohen
Foundation
2001.132

Callum Innes
Exposed Painting, Titanium White on White,
1998
Oil on linen
40 1/2 x 43 1/4 inches
(102.9 x 109.9 cm)
Solomon R. Guggenheim Museum,
New York
Partial and promised gift, The Bohen
Foundation
2001.133

Robert Irwin (b. 1928)
Soft Wall, The Pace Gallery, New York, 1974
Transparent polyester material and
fluorescent and incandescent light
Dimensions site-determined
Overall dimensions of installation at
The Pace Gallery: 120 x 660 x 216 inches
(304.8 x 1676.4 x 548.6 cm)
Overall dimensions of installation at
Guggenheim Museum: 204 x 818 1/8 x 240
inches (518.2 x 2078 x 609.6 cm)
Panza Collection, Gift to F.A.I. (Fondo per
l'Ambiente Italiano), 1996, on permanent loan
to the Solomon R. Guggenheim Foundation,
New York
L241.93

Donald Judd (1928–1994)
Untitled, 1968
Perforated 12-gauge cold-rolled steel
8 x 120 x 66 inches
(20.32 x 304.8 x 167.64 cm)
Solomon R. Guggenheim Museum,
New York
Panza Collection
91.3712

Donald Judd
Untitled, December 23, 1969
Copper, ten units with 9-inch intervals
Overall: 171 x 40 x 31 inches
(434.3 x 101.6 x 78.7 cm)
Solomon R. Guggenheim Museum,
New York
Panza Collection
91.3713

Donald Judd
Untitled, February 1, 1973
Brass and red fluorescent Plexiglas, six units
with 8-inch intervals
Overall: 34 x 244 x 34 inches
(86.4 x 619.8 x 86.4 cm)
Solomon R. Guggenheim Museum,
New York
Panza Collection
91.3719

Ellsworth Kelly (b. 1923)
Orange/Red Relief, 1959
Oil on canvas, two panels

Overall: 60 x 60 inches (152.4 x 152.4 cm)
Solomon R. Guggenheim Museum,
New York
Gift of the artist
96.4511

Ellsworth Kelly
Blue, Green, Yellow, Orange, Red, 1966
Oil on canvas, five panels
Overall: 60 x 240 inches(152.4 x 609.6 cm)
Solomon R. Guggenheim Museum,
New York
67.1833

Ellsworth Kelly
White Angle, 1966
Painted aluminum
72 1/4 x 36 x 72 1/4 inches
(183.5 x 91.4 x 183.5 cm)
Solomon R. Guggenheim Museum,
New York
Gift of the artist
72.1997

Koo Jeong-a (b. 1967)
Oslo, 1998
Crushed aspirin, wood, and blue light
Dimensions variable
Solomon R. Guggenheim Museum,
New York
Purchased with funds contributed by the
Young Collectors Council
2003.62

Joseph Kosuth (b. 1945)
*Box, Cube, Empty, Clear, Glass—
a Description*, 1965
Five glass cubes with silkscreened
lettering
Each: 40 x 40 x 40 inches
(101.6 x 101.6 x 101.6 cm)
The Panza Collection

Wolfgang Laib (b. 1950)
*The Five Mountains Not to Climb On
(Die fünf unbesteigbaren Berge)*, 1984
Hazelnut pollen
Height: approximately 2 3/4 inches (7 cm)
Collection of the artist

Sherrie Levine (b. 1947)
White Knot: 1, 1986
Casein on plywood
31 1/4 x 24 1/4 inches (79.4 x 61.6 cm)
Solomon R. Guggenheim Museum,
New York
Purchased with funds contributed by the
International Director's Council and
Executive Committee Members: Ruth
Baum, Edythe Broad, Dimitris
Daskalopoulos, Harry David, Gail May
Engelberg, Shirley Fiterman, Nicki Harris,
Linda Macklowe, Peter Norton, Tonino
Perna, Elizabeth Richebourg Rea, Mortimer
D. A. Sackler, Simonetta Seragnoli, David
Teiger, and Elliot Wolk
2003.78

Sherrie Levine
White Knot: 9, 1986
Casein on plywood
31 1/4 x 21 1/4 inches (79.4 x 61.6 cm)
Courtesy Paula Cooper Gallery,
New York

Sol LeWitt (b. 1928)
*Wall Drawing #264. A wall divided into 16
equal parts with all one-, two-, three-, and
four-part combinations of lines in four
directions and four colors.*
First installation: Varese, July 1975
Red, yellow, blue, and black pencil
Site-specific dimensions
Solomon R. Guggenheim Museum,
New York
Panza Collection, Gift
92.4156

Sol LeWitt
*Wall Drawing #271. Black circles, red grid,
yellow arcs from four corners, blue arcs
from the midpoints of four sides.*
First installation: Varese, July 1975
Colored pencil
Site-specific dimensions
Solomon R. Guggenheim Museum,
New York
Panza Collection, Gift
92.4157

Glenn Ligon (b. 1960)
Untitled, 2002
Coal dust, printing ink, oil stick, glue,
acrylic paint, and gesso on canvas
74 7/8 x 118 1/8 inches (190 x 300 cm)
Courtesy of the artist and D'Amelio Terras,
New York

Glenn Ligon
Untitled (Rage) #1, 2002
Coal dust, printing ink, oil stick, glue,
acrylic paint, and gesso on canvas
74 7/8 x 81 1/2 inches (190.2 x 207 cm)
Courtesy of the artist and D'Amelio Terras,
New York

Richard Long (b. 1945)
Untitled, 1967
Twigs, 420 units
Overall: approximately 85 13/16 x 84 7/8
inches (218 x 215.5 cm)
Solomon R. Guggenheim Museum,
New York
Panza Collection
91.3749

Robert Mangold (b. 1937)
Neutral Pink Area, 1966
Oil on Masonite, two panels
Overall: 48 x 96 inches (121.9 x 243.8 cm)
Solomon R. Guggenheim Museum,
New York
Panza Collection
91.3759

Robert Mangold
1/2 Manilla Curved Area (Divided), 1967
Oil on Masonite, four panels
Overall: 48 x 192 inches (121.9 x 487.6 cm)
Solomon R. Guggenheim Museum,
New York
Gift, Donald Droll
71.1961

Piero Manzoni (1933–1963)
Achrome, 1958
Kaolin on creased canvas
25 1/2 x 19 3/4 inches (65 x 50 cm)
Courtesy Michael Werner Gallery,
New York and Cologne

Piero Manzoni
Achrome, 1960
Kaolin on canvas
24 1/2 x 30 inches (61.5 x 76 cm)
Courtesy Michael Werner Gallery,
New York and Cologne

Brice Marden (b. 1938)
Private Title, 1966
Oil and wax on canvas
47 3/4 x 95 3/4 inches (121.3 x 243.2 cm)
Solomon R. Guggenheim Museum,
New York
Panza Collection
91.3782

Brice Marden
D'après la Marquise de la Solana, 1969
Oil and wax on canvas, three panels
Overall: 77 5/8 x 117 3/8 inches
(197.2 x 298.2 cm)
Solomon R. Guggenheim Museum,
New York
Panza Collection
91.3784

Brice Marden
Untitled, 1973
Oil and wax on canvas, two panels
Overall: 72 x 72 1/8 inches
(182.9 x 183.2 cm)
Solomon R. Guggenheim Museum,
New York
Panza Collection
91.3789

Agnes Martin (b. 1912)
Untitled, 1960
Black ink on tracing paper
11 7/8 x 9 3/8 inches (30.2 x 23.8 cm)
Solomon R. Guggenheim Museum,
New York
Gift, Estate of Geraldine Spreckels Fuller
2000.39

Agnes Martin (b. 1912)
White Flower, 1960
Oil on canvas
71 7/8 x 72 inches (182.6 x 182.9 cm)
Solomon R. Guggenheim Museum,
New York
Anonymous gift
63.1653

Agnes Martin
Little Sister, 1962
Oil, pencil, and nailheads on canvas,
mounted on panel
9 7/8 x 9 11/16 inches (25.1 x 24.2 cm)
Solomon R. Guggenheim Museum,
New York
Gift, Estate of Geraldine Spreckels Fuller
2000.40

Agnes Martin
White Stone, 1965
Oil and graphite on linen
71 7/8 x 71 7/8 inches (182.6 x 182.6 cm)
Solomon R. Guggenheim Museum,
New York
Gift, Mr. Robert Elkon
69.1911

Allan McCollum (b. 1944)
Collection of Twenty Plaster Surrogates,
1982/84
Enamel on Hydrostone
Overall dimensions vary with installation
Collection of the artist

John McCracken (b. 1934)
Naxos, 1965
Wood, fiberglass, and lacquer
15 x 16 1/2 x 7 inches
(38.1 x 41.9 x 17.8 cm)
Solomon R. Guggenheim Museum,
New York
Gift, Mrs. Andrew P. Fuller
71.1979

John McCracken
Blue Plank, 1969
Polyester resin on fiberglass and plywood
94 1/2 x 22 1/4 x 3 1/8 inches
(239.4 x 56.5 x 8 cm)
Solomon R. Guggenheim Museum,
New York
Gift, Robert Elkon
70.1934

John McCracken
Pink Block (2), 1969
Polyester resin on fiberglass and plywood
10 x 10 1/2 x 8 1/4 inches
(25.4 x 26.6 x 21 cm)
Solomon R. Guggenheim Museum,
New York
Gift, Robert Elkon
73.2043

Robert Morris (b. 1931)
Untitled (Warped Bench), 2004
refabrication of a 1965 original
Painted plywood
18 x 96 x 18 inches
(45.72 x 243.84 x 45.72 cm)
Solomon R. Guggenheim Museum,
New York
Panza Collection
91.3793

Robert Morris
Untitled (Quarter-Round Mesh), 1967
Steel grating
31 x 109 x 109 inches (79 x 277 x 277 cm)
Solomon R. Guggenheim Museum,
New York
Panza Collection
91.3799

Bruce Nauman (b. 1941)
Bouncing in the Corner, No. 1, 1968
Black and white video with sound
60 minutes, to be repeated continuously
Courtesy Electronic Arts Intermix (EAI)

Bruce Nauman
Manipulating a Fluorescent Tube, 1969
Black and white video with sound
60 minutes, to be repeated continuously
Courtesy Electronic Arts Intermix (EAI)

Bruce Nauman
Lighted Performance Box, 1969
Aluminum and 1,000-watt spotlight
78 x 20 x 20 inches
(198.1 x 50.8 x 50.8 cm)
Solomon R. Guggenheim Museum,
New York
Panza Collection
91.3820

Bruce Nauman
Triangular Depression, 1977
Plaster, burlap, steel mesh, and steel rods
21 x 121 x 103 inches
(53.3 x 307.3 x 261.6 cm)
The Museum of Modern Art, New York
Gift of Werner and Elaine Dannheisser, 1996
Solomon R. Guggenheim Museum,
New York
Fractional gift, Werner Division
91.3901

Roman Opalka (b. 1931)
1965/ 1-∞; Detail 1,520,432 - 1,537,871, 1965
Acrylic on canvas, with audio recording
77 1/4 x 53 1/4 inches (196.2 x 135.2 cm)
Solomon R. Guggenheim Museum,
New York
76.2220

Robert Rauschenberg (b. 1925)
White Painting [seven panel], 1951
Oil on canvas
72 x 125 x 1 1/2 inches
(182.9 x 317.5 x 3.81 cm)
Collection of the artist

Charles Ray (b. 1953)
Table, 1990
Plexiglas and steel
Edition of 3
38 1/4 x 35 5/8 x 52 3/4 inches
(97.2 x 90.5 x 134 cm)
Collection of Mandy and Cliff Einstein

Ad Reinhardt (1913–1967)
Abstract Painting, 1960–66
Oil on canvas
60 x 60 inches (152.4 x 152.4 cm)
Solomon R. Guggenheim Museum,
New York
By exchange
93.4239

Gerhard Richter (b. 1932)
4 Panes of Glass (4 Glasscheiben), 1967
Exhibition copy
Glass and metal, in four parts
Each: 74 13/16 x 39 3/8 inches
(190 x 100 cm)
Collection Herbert, Ghent

Gerhard Richter
Passage (Durchgang), 1968
Oil on canvas
78 3/4 x 78 3/4 inches (200 x 200 cm)
Solomon R. Guggenheim Museum,
New York
Gift, The Theodoron Foundation
69.1904

Dorothea Rockburne (b. 1921)
A Drawing Which Makes Itself, 1972
Pencil on paper
29 3/4 x 39 1/2 inches (75.5 x 100.4 cm)
Solomon R. Guggenheim Museum,
New York
Gift, Leon Hecht
81.2879

Robert Ryman (b. 1930)
Classico IV, 1968
Acrylic on twelve sheets of handmade
Classico paper mounted on foamcore
Overall: approximately 91 x 89 1/2 inches
(231.1 x 227.3 cm)
Solomon R. Guggenheim Museum,
New York
Panza Collection
91.3845

Robert Ryman
Untitled (Whitney Revision Painting 3), 1969
Enamelac on corrugated cardboard,
three units
Overall: 60 x 215 inches (152.4 x 546.1 cm)
Solomon R. Guggenheim Museum,
New York
Panza Collection
91.3849

Robert Ryman
Surface Veil I, 1970
Oil and blue chalk on stretched linen
canvas
143 15/16 x 144 inches (365.6 x 365.8 cm)
Solomon R. Guggenheim Museum,
New York
Panza Collection
91.3851

Robert Ryman
Surface Veil II, 1971
Oil and blue chalk on stretched
linen canvas
144 x 144 inches (365.8 x 365.8 cm)
Solomon R. Guggenheim Museum,
New York
Panza Collection
91.3854

Robert Ryman
Surface Veil III, 1971
Oil and blue chalk on stretched
cotton canvas
144 1/4 x 144 1/4 inches (366.4 x 366.4 cm)
Solomon R. Guggenheim Museum,
New York
Panza Collection
91.3855

Robert Ryman
Marshall, 1998
Oil and acrylic on linen
23 x 23 inches (58.4 x 58.4 cm)
Collection Arne and Milly Glimcher

Robert Ryman
Resort, 2001
Oil on linen
36 x 36 inches (91.4 x 91.4 cm)
Private Collection, courtesy of
PaceWildenstein

Karin Sander (b. 1957)
Chicken's Egg, Polished, Raw, Size 0, 1994
Collection of the artist

Karin Sander (b. 1957)
Wallpiece, 2004
Polished wall paint
Site-specific installation, Guggenheim
Museum
Collection of the artist

Richard Serra (b. 1939)
Shovel Plate Prop, 1969
Steel, two units
Overall: 80 x 84 x 32 inches
(203 x 213.4 x 81.3 cm)
Solomon R. Guggenheim Museum,
New York
Panza Collection
91.3867

Richard Serra
Right Angle Prop, 1969
Lead antimony
72 x 72 x 34 inches (182.9 x 182.9 x 86.4 cm)
Solomon R. Guggenheim Museum,
New York
Purchased with funds contributed by
The Theodoron Foundation
69.1906

Richard Serra
Close Pin Prop, 1969
Lead antimony
90 x 6 x 100 inches (229 x 15.2 x 254 cm)
Solomon R. Guggenheim Museum,
New York
Panza Collection
91.3870

Tony Smith (1912–1980)
For W.A., 1969
Welded bronze with black patina
Edition 1/6
Each unit: 60 x 33 x 33 inches
(152 x 83.3 x 83.3 cm)
Solomon R. Guggenheim Museum,
New York
Purchased with the aid of funds from the
National Endowment for the Arts in
Washington, D.C., a Federal Agency;
matching funds contributed by the
Junior Associates Committee
80.2753

Ettore Spalletti (b. 1940)
Vaso, 1981–92
Paint on wood
Height: 49 3/16 inches (125 cm);
diameter, maximum: 39 3/8 inches
(100 cm) minimum: 35 7/16 inches (90 cm)
Solomon R. Guggenheim Museum,
New York
Gift of the artist
93.4242

Ettore Spalletti
Alto, 1992
Powdered pigment on wood, two panels
Each: 110 1/4 x 55 1/8 inches (280 x 140 cm)
Solomon R. Guggenheim Museum,
New York
Gift of the artist
93.4243

Frank Stella (b. 1936)
Point of Pines, 1959
Enamel on canvas
84 3/4 x 109 1/8 inches (215.3 x 277.2 cm)
Collection of the artist

Rudolf Stingel (b. 1956)
untitled, 2000
Styrofoam, four panels
Overall: 96 x 192 x 4 inches
(243.8 x 487.7 x 10.2 cm)
Courtesy of the artist and Paula Cooper
Gallery, New York

Hiroshi Sugimoto (b. 1948)
Mediterranean, La Ciotat 2 (D), 1989
Black-and-white photograph
Edition 4/25
20 x 24 inches (50.8 x 61.0 cm)
Solomon R. Guggenheim Museum,
New York
Partial and promised gift, The Bohen
Foundation
2001.267

Hiroshi Sugimoto
Tasman Sea, Ngarupupu, 1990
Black-and-white photograph
Edition 5/25
20 x 24 inches (50.8 x 61.0 cm)
Solomon R. Guggenheim Museum,
New York
Partial and promised gift, The Bohen
Foundation
2001.268

Hiroshi Sugimoto
Tyrrhenian Sea, Amalfi, 1990
Black-and-white photograph
Edition 11/25
20 x 24 inches (50.8 x 61.0 cm)
Solomon R. Guggenheim Museum,
New York
Partial and promised gift, The Bohen
Foundation
2001.269

Hiroshi Sugimoto
Black Sea, Ozuluce, 1991
Black-and-white photograph
Edition 14/25
20 x 24 inches (50.8 x 61.0 cm)
Solomon R. Guggenheim Museum,
New York
Partial and promised gift, The Bohen
Foundation
2001.270

Hiroshi Sugimoto
Bay of Sagami, Atami, 1997
Black-and-white photograph
Edition 11/25
20 x 24 inches (50.8 x 61.0 cm)
Solomon R. Guggenheim Museum,
New York
Partial and promised gift, The Bohen
Foundation
2001.275

Hiroshi Sugimoto
Bay of Sagami, Atami, 1997
Black-and-white photograph
Edition 16/25
20 x 24 inches (50.8 x 61.0 cm)
Solomon R. Guggenheim Museum,
New York
Partial and promised gift, The Bohen
Foundation
2001.276

James Turrell (b. 1943)
Afrum I, 1967
MSR lamp projection, 1,200-watts
Dimensions variable
Solomon R. Guggenheim Museum,
New York
Panza Collection, Gift
92.4175

Meg Webster (b. 1944)
Cono di Sale, June 1988
Salt
Height: 72 inches (182.9 cm);
Diameter: 96 inches (243.8 cm)
Solomon R. Guggenheim Museum,
New York
Panza Collection
92.4082

Lawrence Weiner (b. 1942)
Cat. #278 (1972)
TO SEE AND BE SEEN, 1972
Language and the materials referred to
Dimensions variable
Solomon R. Guggenheim Museum,
New York
Panza Collection, Gift
92.4193

Doug Wheeler (b. 1939)
Untitled (Environmental Light),
Los Angeles, 1969–70
Installation with neon
Dimensions site-specific
Dimensions of original installation
at Ace Gallery: 180 x 352 x 352 inches
(457 x 894 x 894 cm)
Dimensions of installation at Guggenheim
Museum: 192 x 339 x 372 inches
(488 x 861 x 945 cm)
Solomon R. Guggenheim Museum,
New York
Panza Collection, Gift
91.4086

Rachel Whiteread (b. 1963)
Untitled (One Hundred Spaces), 1995
Resin, 100 units
Overall dimensions variable
Courtesy Anthony d'Offay Gallery, London

Contributors

Andrea Codrington is a New York–based critic specializing in design and visual culture.

Drew Daniel is a Ph.D. candidate in the English Department at the University of California at Berkeley, where he is writing a dissertation on melancholy in English literature and visual art between 1590 and 1660. He is also a member of the experimental electronic band Matmos.

Bruce Jenkins is the Stanley Cavell Curator of the Harvard Film Archive and Senior Lecturer in Visual and Environmental Studies at Harvard University.

Gia Kourlas is the dance editor of *Time Out New York*.

Deyan Sudjic is a critic and curator based in London, where he is currently architectural correspondent for *The Observer*. He was, until recently, editor of *Domus*, and the director of the Venice Architecture Biennale in 2002.

Mark C. Taylor is Cluett Professor of Humanities at Williams College and Visiting Professor of Architecture and Religion at Columbia University.

Photo Credits